David Wilson
children

RotoVision

A RotoVision Book
Published and Distributed by RotoVision SA
Rue Du Bugnon 7
1299 Crans-Près-Céligny
Switzerland

RotoVision SA, Sales & Production Office
Sheridan House, 112/116A Western Road
Hove, East Sussex BN3 1DD, UK

Tel: +44 (0) 1273 72 72 68
Fax: +44 (0) 1273 72 72 69
E-mail: sales@rotovision.com
Website: www.rotovision.com

10 9 8 7 6 5 4 3 2 1

ISBN 2-88046-535-4

Book design by Kate Stephens

Production and separations in Singapore
by ProVision Pte. Ltd
Tel: +65 334 7720
Fax: +65 334 7721

Printed and Bound in China by Midas Printing

David Wilson
children

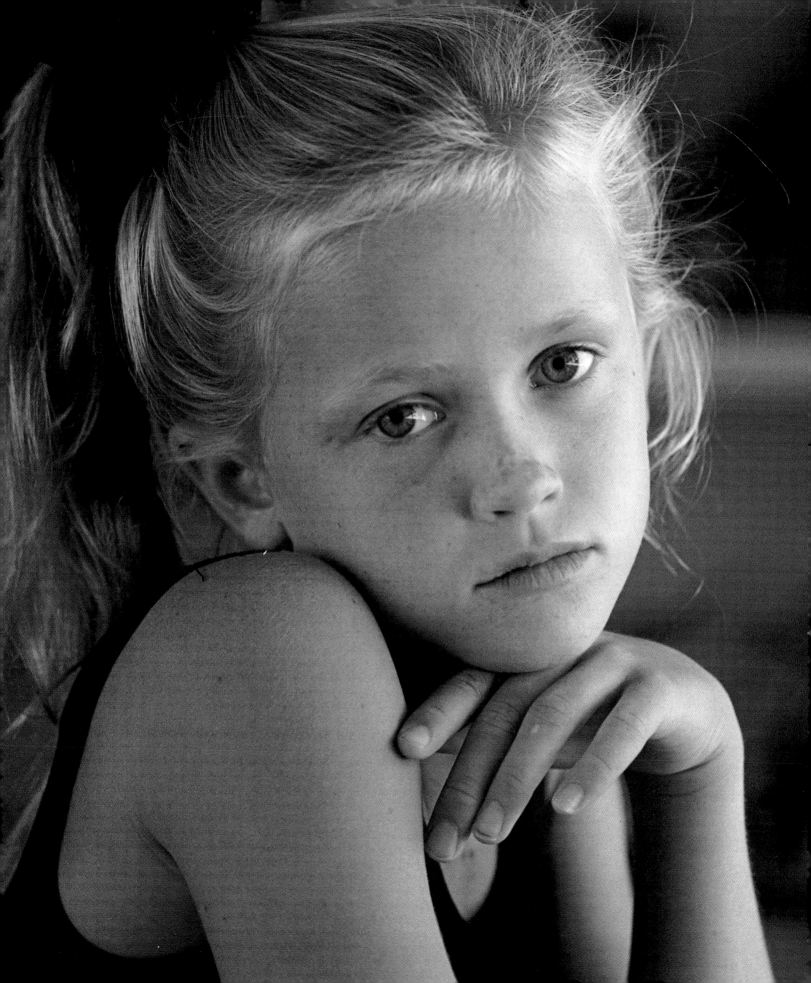

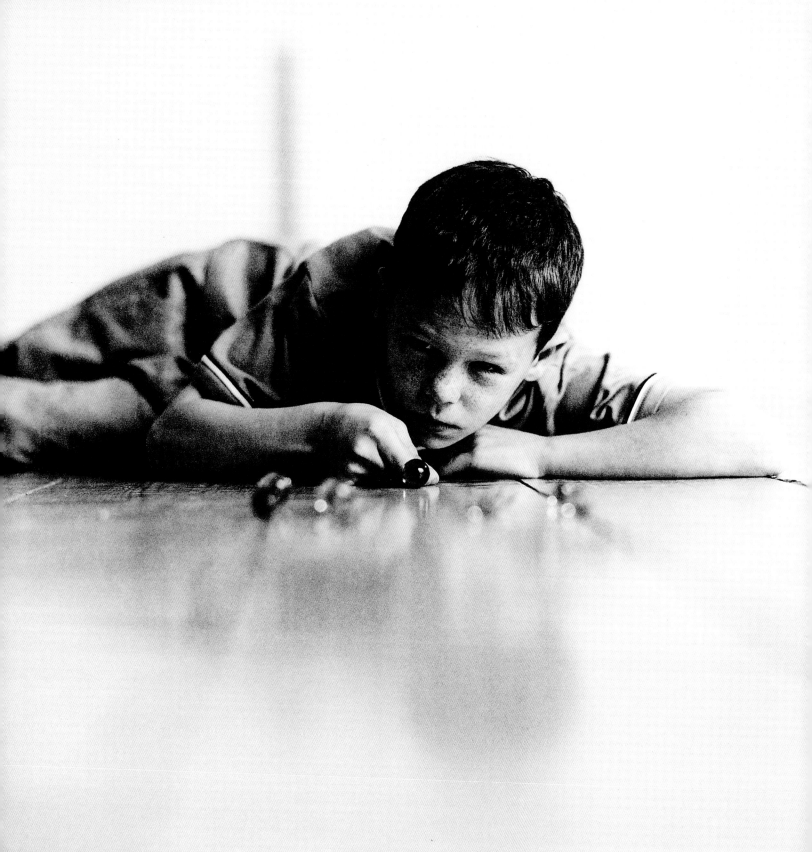

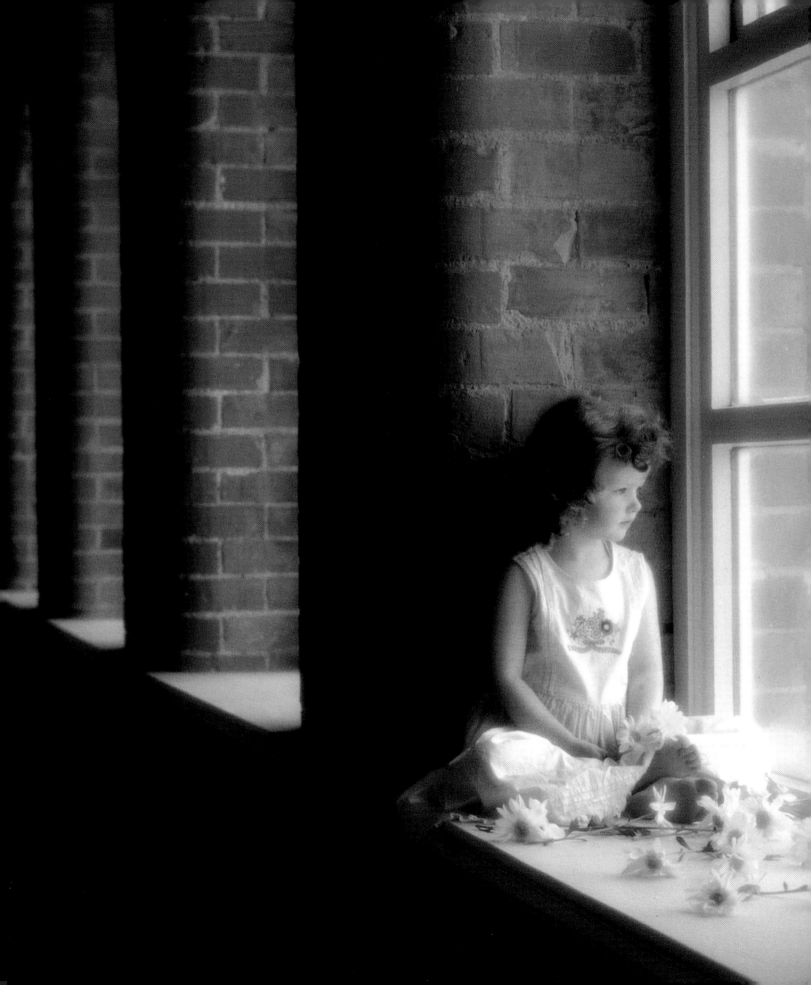

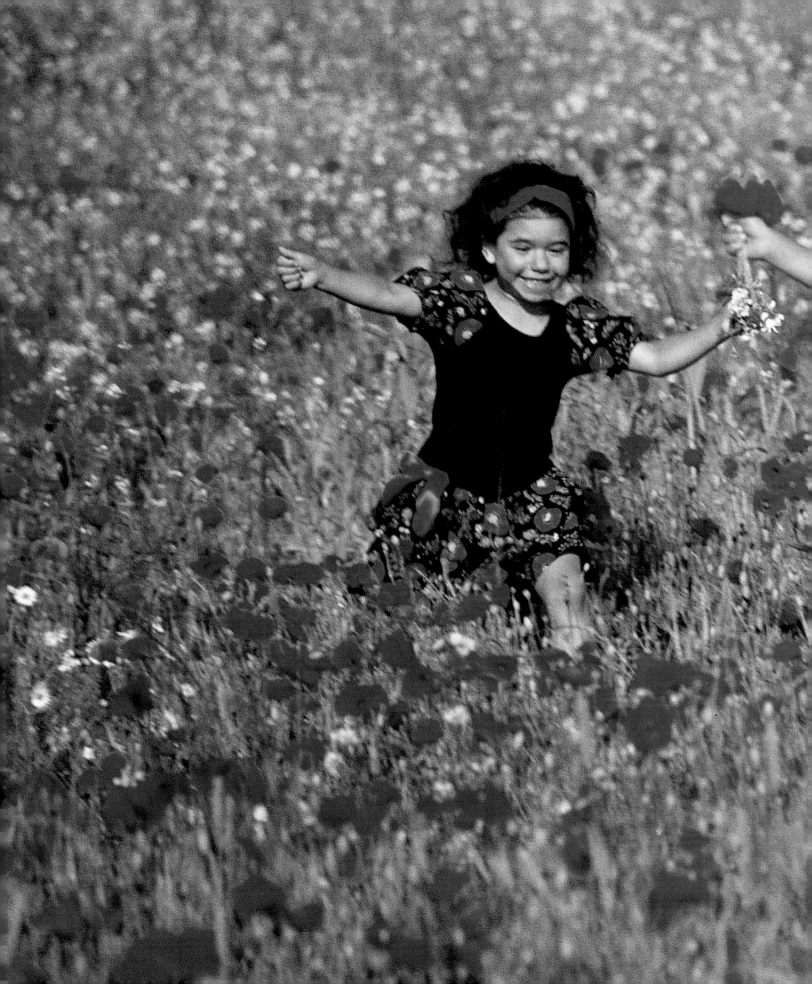

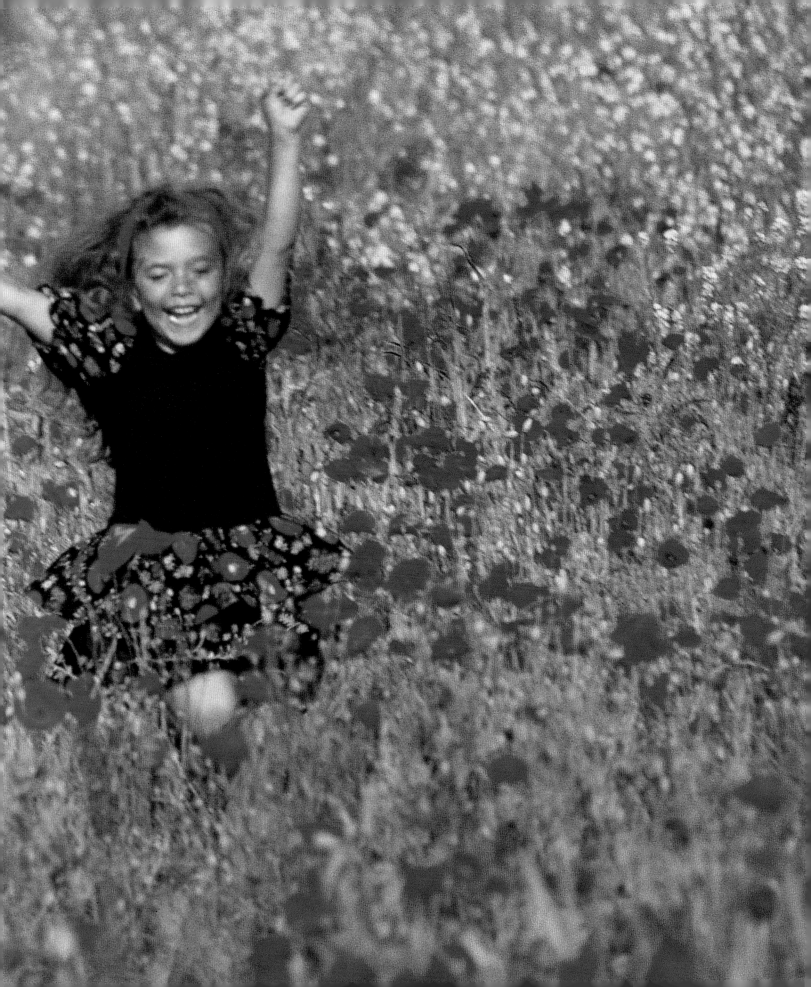

1 **contemporary photography** **16**

2 **what the clients want** **26**

3 **real-life shoots** **36**

4 **developing a relationship** **48**

5 **styling and art directing** **62**

6 **studio lighting** **76**

7 **on location** **94**

8 **editing and cropping** **110**

9 **presentation and printing** **120**

10 **marketing and websites** **136**

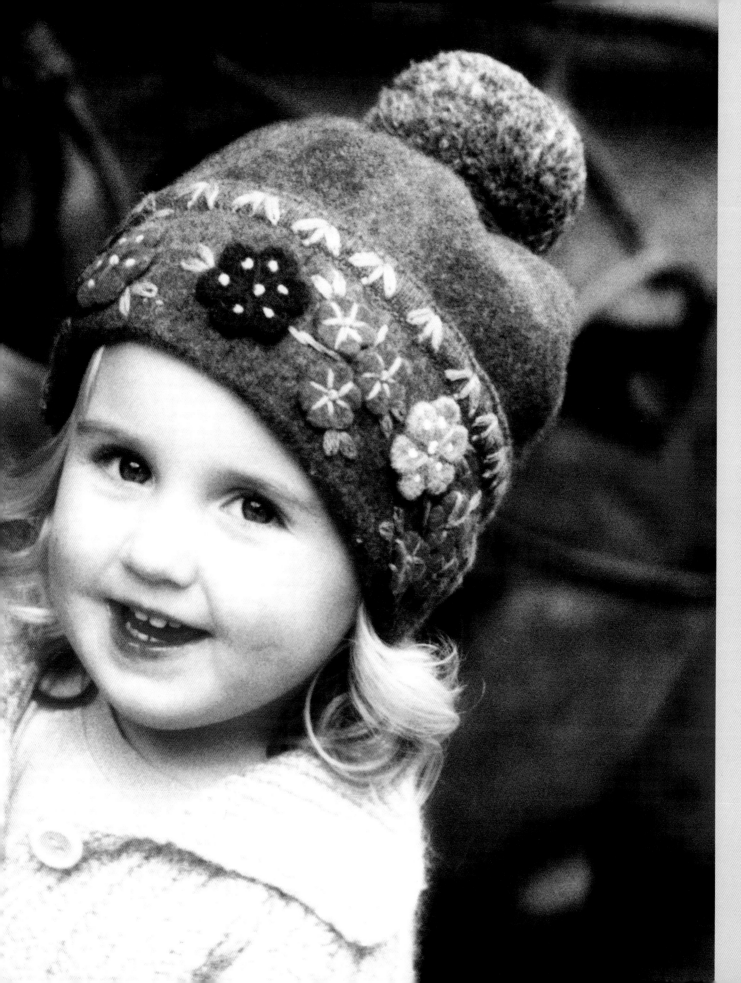

Children's portraiture is changing. Gone are the cheesy grins and the awkward pose beside the aspidistra – today's clients want a more contemporary, stylish look. The new social photography is bright and dynamic, drawing much of its inspiration from youth culture and from fashion and lifestyle photography.

At the same time it's more relaxed. Parents want pictures that show their children looking their best, but they also want pictures that show happy children behaving naturally – in essence, pictures that capture a candid, carefree moment of childhood. This applies in equal measure to the studio portrait and to the location shoot outdoors. And although parents want their children portrayed in a manner that is up-to-the-minute, they don't want pictures that will soon appear dated. The new look is fresh and modern, but the best examples of it also have a timeless quality.

For the photographer, these contemporary demands require a new way of thinking. It's time to abandon the clichéd poses and standard studio backgrounds that have held sway for so long and embrace a more modern way of working. Informality is the key to the contemporary style, and photographers should not be shy of experimenting. Relaxing the rules of the studio session, moving the shoot to an outdoors location or injecting humour into the proceedings are all ways that can help to achieve the required look.

Needless to say, the most successful photographers of children are not simply those who have an eye for fashion but those who enjoy a natural empathy with their young subjects. The following pages contain the work of a number of photographers who have established their own distinctive styles and who have built up a solid base of clients who return to them again and again. Their ways of working and the looks they create are very different, but they are united by the fact that they regard child portrait photography as more than merely a job – they actually think it's fun.

"This wasn't very difficult to do – all I needed was a vignetting mask, a warm-tone diffusion filter and a forest," says Margo van der Vooren. The young subject is her son Mick: she frequently uses her own two children as models when she's experimenting with a new technique or trying out a piece of equipment. Keeping it in the family also means that she can set up pictures at a moment's notice to take advantage of favourable lighting conditions. "If you've got an appointment with a client and the light is wrong, you either have to think of a different approach or postpone the shoot," she explains. This shot, incidentally, won her a European Kodak Gold Award, and her early success encouraged her to enter competitions on a regular basis. "They stimulate me to keep improving my work," she says.

Hasselblad, 150mm lens, Kodak Vericolor 160 Pro. Exposure of 1/125sec, with vignetting mask and Softar warm-tone diffusion filter.

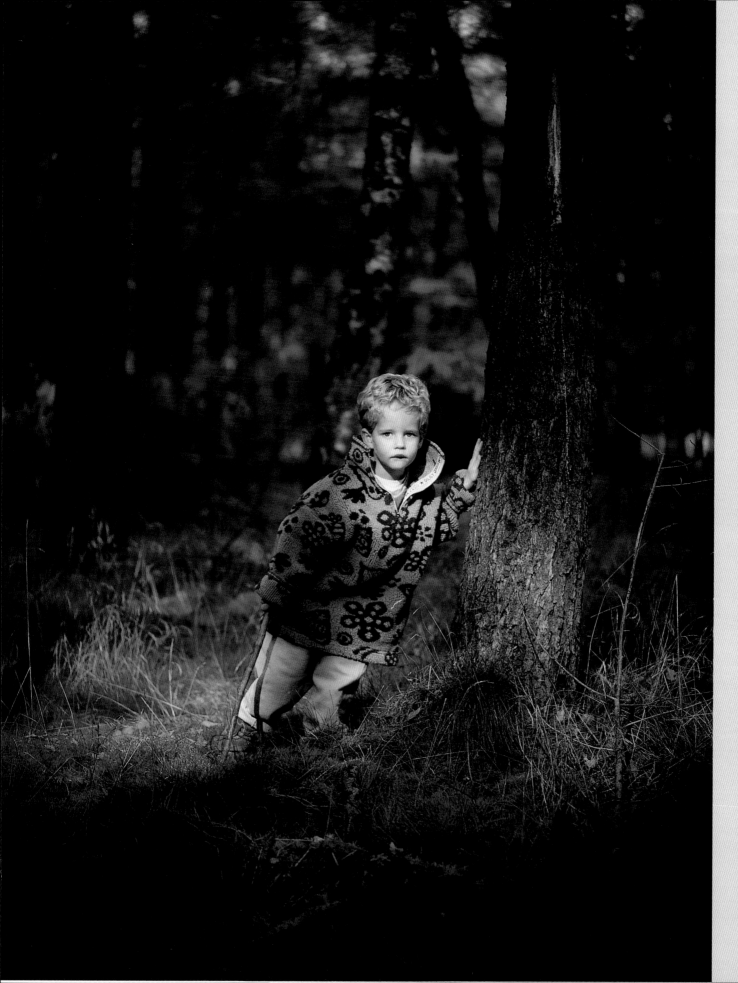

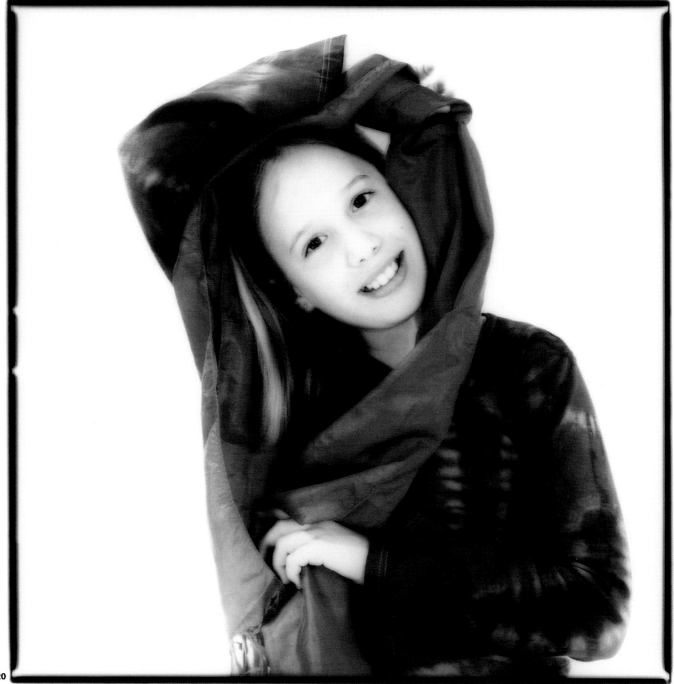

Margo van der Vooren works hard at building up a rapport with her young subjects. Treating the session as a game is one of the techniques she uses. "I like making different shapes with the body," she says. "First I do it, then the child copies."

Hasselblad, 150mm macro lens and Kodak Ektachrome 100 Plus cross-processed in C-41 chemicals. Lighting from two softboxes angled at 45 degrees to either side of the camera. Exposure 1/60sec at f/11.

For this shot Margo van der Vooren used a plain white background, but in the course of the session she tried out a variety of coloured backdrops to complement the different clothes the young model was wearing. She sometimes makes graffiti drawings on the backgrounds to make them 'busier' by breaking up the areas of solid colour. Cross-processing created vibrant colours and a contemporary feel reminiscent of a fashion magazine.

Hasselblad, 150mm macro lens and Kodak Ektachrome 100 Plus cross-processed in C-41 chemicals. Lighting from two softboxes angled at 45 degrees to either side of the camera. Exposure 1/60sec at f/11.

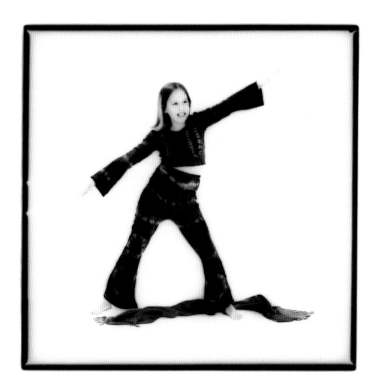

Many of Margo van der Vooren's clients want something 'different' – although they're not always sure themselves what this may be. To establish a style, she takes parents through examples of her previous work until she hits on the look they like the best.

The family of this girl liked the effect created by cross-processing. This technique involves shooting on colour transparency film but processing it in the C-41 chemicals normally used for colour negative emulsions, then making a print. It creates bright, vibrant colours and has an unmistakably contemporary feel.

Van der Vooren works mostly in the studio and asks her clients to bring along as many changes of bright clothing as possible on the day of the shoot. This allows her to make her own selection of clothing and to try out different styles. If she leaves the choice to the parents, she often finds herself struggling to create the look she wants to achieve. "I go with the flow and try out whatever pops into my mind," she explains. "Sometimes a normal session can turn into an out-and-out fashion shoot."

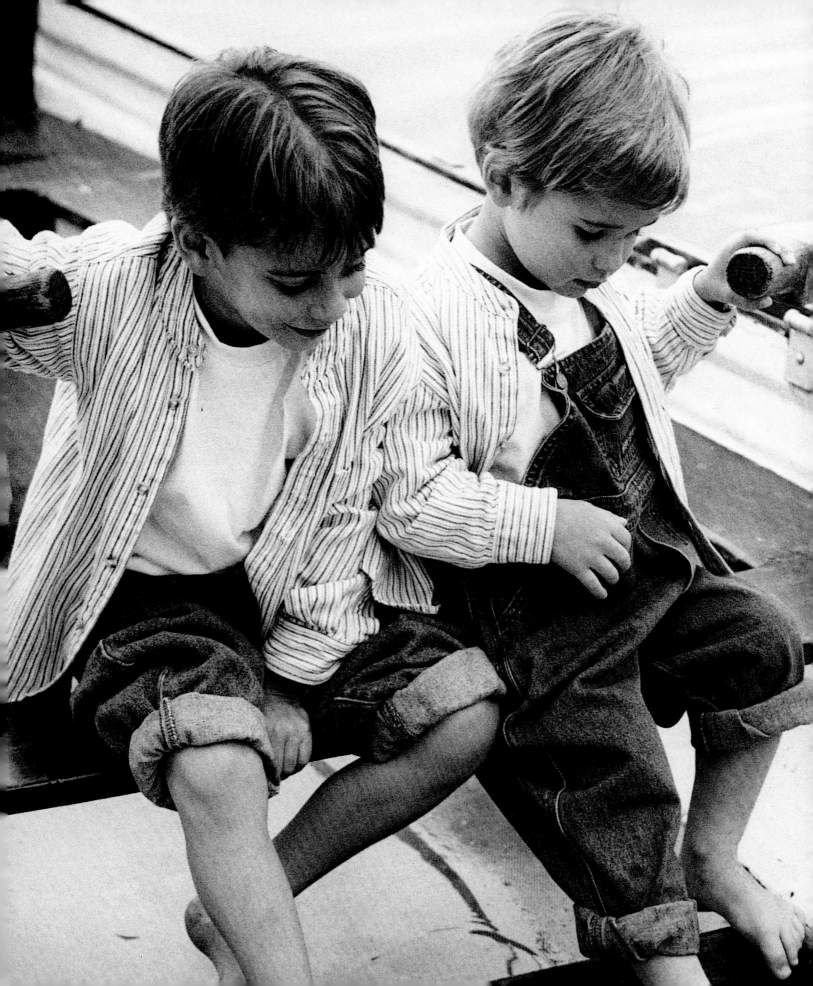

> ## "I believe photographs should reflect the clients' lifestyle and be relaxed, natural and spontaneous."
>
> **Annabel Williams**

The new style means portraying subjects in a relaxed and natural manner. "It's 10 per cent photography and 90 per cent psychology, making sure the clients have a really good experience," says Annabel Williams, one of its leading practitioners. "With children, it's about relating to them and making them feel interested in what you're doing – as though you're there as a friend and they're modelling for you. I always leave the cameras in the car when I first arrive at a client's house, and I never try to get children excited, because you just lose the plot."

Williams doesn't advertise: all her marketing is done by reputation and through word-of-mouth. A typical session takes about half a day. "Not all of that is shooting, a lot of it is spent having coffee, chatting to people, walking around the location and generally relating to the client," says Williams. "You have to develop a relationship with people in order to really enjoy photographing them. By talking to them over a coffee, you find out what they're like, what they do, and they start to relax."

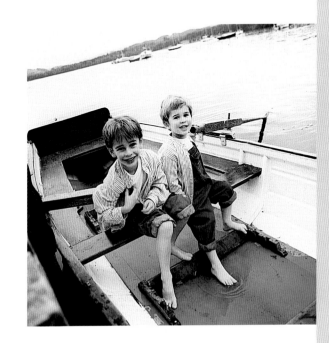

"Everyone thinks that a good picture is a smile, but I disagree with that," says Annabel Williams. "Parents like their children to smile, so I always get a smiley picture, but I love children when they don't smile. They look so much more natural and it gets more mood into the picture. There's a big difference between looking miserable and just looking soft and natural, and you're trying to get every mood of the child rather than them just smiling at the camera. Parents love the moody pictures too."

Canon EOS 5, 75-300mm zoom, Fuji Neopan 1600. Exposure 1/500sec at f/5.6. Sepia toned.

"I like square images. You can crop things later but I prefer to get the format right to start with – it affects the way you shoot it," says Annabel Williams. She usually shoots with an aperture of f/5.6, to throw the background out of focus, and tilts the camera at an angle, which gives the image a more dynamic feel. "I like the slant because it takes the reality out of the background; it reduces it to just a colour," she explains. "It puts the emphasis on the person rather than on the whole scene."

Hasselblad, 120mm lens, Fujichrome Provia 400 cross-processed in C-41 chemicals. Exposure 1/250sec at f/5.6

This was shot at one of Annabel Williams' favourite locations, a working industrial estate near her studio, which provides her with an ever-changing choice of backgrounds. The day of the shoot was cold and wet. "It's not true that everyone's got to wear their best dress for a shoot and that it's got to be sunny. Kids look lovely in woolly hats and cardies and, as long as you expose from the face, it doesn't matter what happens to the background," she says. "The little girl insisted on carrying her favourite basket everywhere with her. I felt that was part of her, and her parents will look back on the picture and remember it."

Hasselblad camera, 120mm lens, Fujichrome Provia 400 cross-processed in C-41 chemicals. Exposure 1/60sec at f/5.6.

Annabel Williams shoots both black-and-white and colour, usually in the same session, but uses 35mm for black-and-white and medium format for colour. "Most clients today prefer black-and-white over colour, so I cross-process all my colour pictures," she explains. "People like colour when it's done that way. It's more vivid and more stylish – it makes their child look like a model in a clothing catalogue or a magazine. Straightforward colour is boring." Her choice of film is Fujichrome Provia 400 slide film, developed in C-41 chemicals (intended for processing print films).

Certain colours work better than others when cross-processed. "Pastel colours – pale pinks and lime-greens, for example – look beautiful in cross-processing, they come out really well," says the photographer. "So does denim. But reds don't work – they tend to bleed into the skin. Stick to soft colours and it will work out fine."

For black-and-white she uses a 35mm SLR with a zoom lens. Her preferred film is Fuji Neopan 1600, a grainy film which she likes for its 'arty' feel. She never uses flash, nor does she use a tripod. "All my pictures are handheld, both 35mm and medium format – a tripod's too restrictive. You have to have the child in the right place and it's all about posing and being rigid," she explains. "The only way to get versatility from a shot is to wander around, zoom in, crop, change the angle, and all in just a few seconds. You zoom in and shoot whatever is going on – it's much more spontaneous."

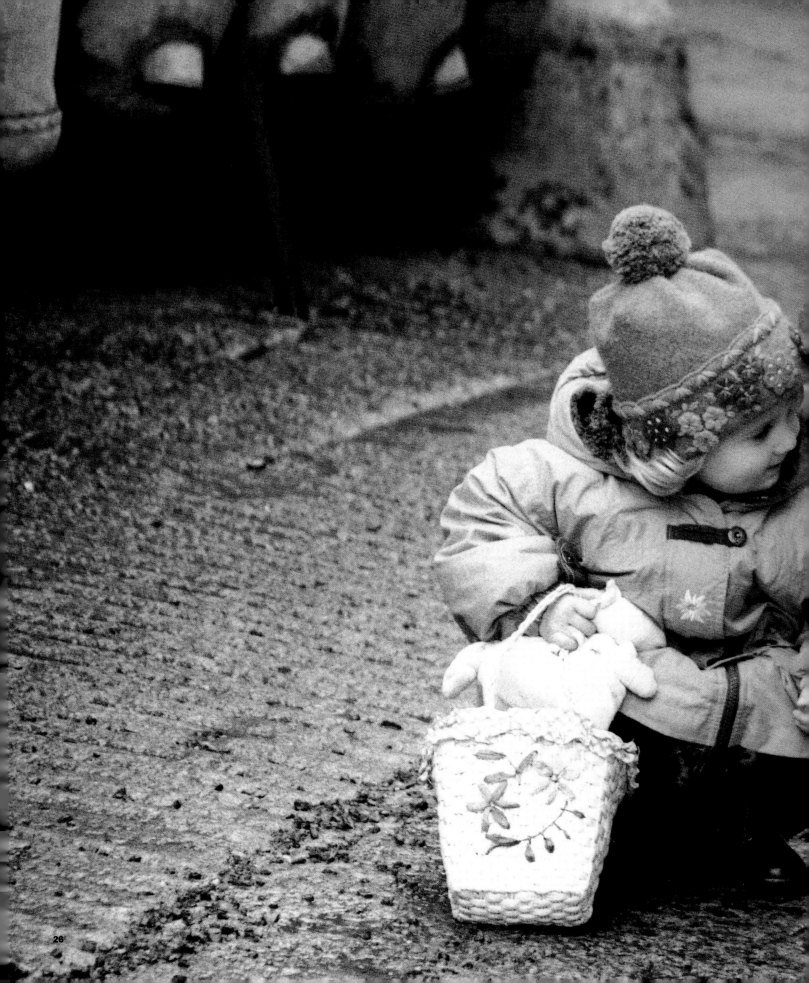

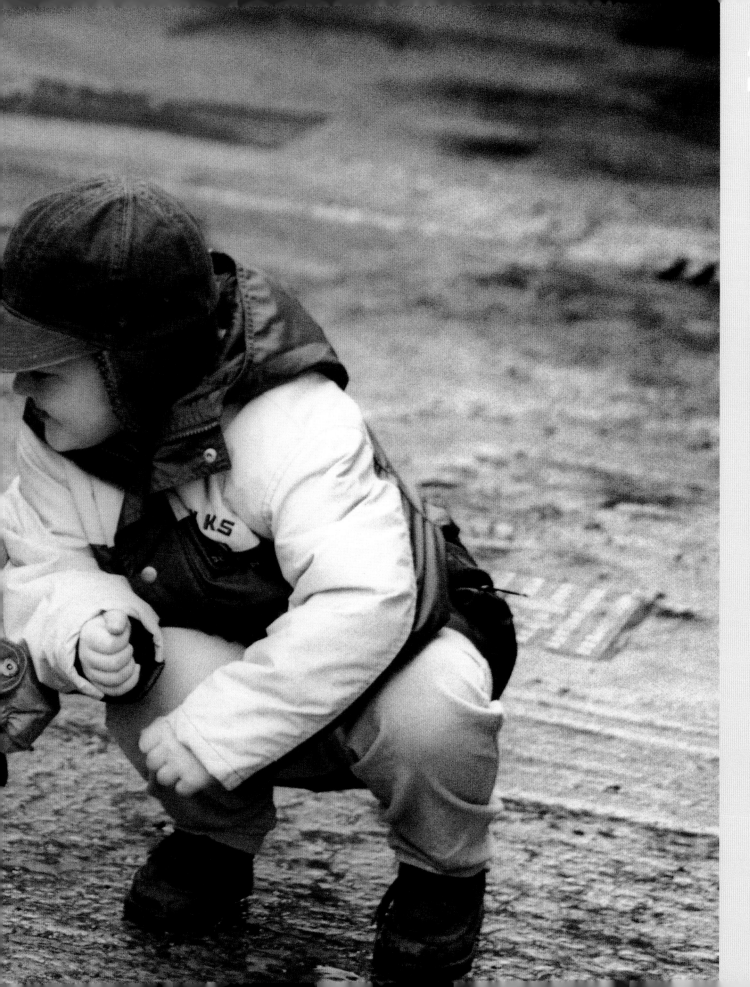

what the clients wantwhat the clients want

what the clients want2

Your clients are parents. It is parents who commission child portraits, and parents who pay for them. There's nothing to stop you experimenting and trying out different styles, but it's wise to steer clear of anything too off-the-wall. If the parents don't like the pictures, you won't sell your work.

Invariably parents want more than just a mugshot. They want pictures that reflect the way they see their their son or daughter and which in years to come will remind them of the way they were. Some parents have in mind a romantic, idealised image of childhood. For others the image is more lifestyle-oriented and aspirational. Either way, the photographer's task is to deliver images that capture a slice of childhood, a moment in time.

Margo van der Vooren had the advantage of working with her own daughter Sabine, but her objective was the same as that of any working professional: to capture the brief moments in the course of a shoot that best encapsulate the character and personality of the child.

Hasselblad, 150mm lens, Kodak Ektachrome 100 Plus cross-processed in C-41 chemicals.

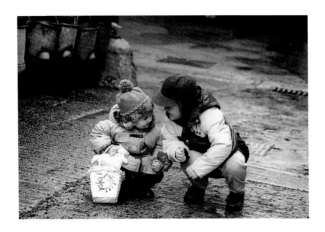

It was very dark and wet the day of Annabel Williams' session with this young brother and sister. "Unfortunately it was pouring down, but it's the same as shooting a wedding: you can't change it, so you just go and do it," she says. The children's mother held an umbrella over them between shots and pulled it away at the right moments. The children themselves were quite happy splashing in the puddles. "You make it fun for them, you get mum and dad involved," says Williams.

"The parents are usually thrilled by the results because they just couldn't imagine it would work so well in the wet. Personally, I much prefer dull light to bright sunshine. It's softer and you don't get harsh shadows."

Canon EOS 5, 75-300mm zoom, Fuji Neopan 1600. Exposure 1/30sec at f/5.6.

Annabel Williams often shoots children with their families. "It's a complete experience – the whole thing is a family event," she says. "I work with a make-up artist and stylist who is there for the whole shoot, so women in particular feel really good about themselves. Mothers never wanted to be in the shot, but now it's totally different. They get a lot of pampering and because they've got their own stylist, it's like going on their own fashion shoot."

The look that Williams creates is strongly inspired by fashion photography. "I don't think people have a specific picture in mind when they come to me, except that they know it will be relaxed and natural and that they'll have a good time," she explains. "But the style is very much related to the pictures that they've seen in magazines and children's clothing catalogues. Those images are around them all the time."

On the day of the shoot, Williams asks her clients to bring two or three different outfits to change into – not too many. She doesn't shoot pictures in formal clothes unless specifically requested. "A lot of people feel they have to dress up, otherwise they haven't made an effort," she explains. "But by the end of the shoot they're always in their normal casual clothes and those are the pictures that they will like the best, although it wasn't necessarily how they felt comfortable at the beginning of the shoot. That's the psychology of it: it's all part of the experience."

"This is what I call today's proper family portrait," says Annabel Williams. "These are today's clients – they want to see the children's faces, they want interaction, with everyone looking happy together. In a way, they want it to look like a professional snapshot: this is actually a very composed picture, carefully lit and done on grainy film, but it looks very casual. It's very much a lifestyle photograph." The background was provided by a pair of garage doors at the back of a pub, just around the corner from her studio. "It shows you don't need lavish trees or lakes as a background – the textures of wood and stone in a painted garage door and a bit of a wall will do just as well," says the photographer.

Canon EOS 5, 75-300mm zoom, Fuji Neopan 1600. Exposure 1/500sec at f/5.6.

"Joy is the most important ingredient for a successful picture," says Margo van der Vooren. Moody portraits can be very successful – and will sell well – but nothing is more likely to appeal to a parent than a picture that captures the sheer, unfettered exuberance of a happy, healthy and well-loved child.

For children to appear natural and uninhibited, the photographer needs to build up a rapport with them. The process of being photographed should be as painless as possible, especially for very young children, so rigid poses, banks of lights and intimidatingly large camera gear should all be avoided. Ideally, the photographer should blend into the background and just let the subjects carry on being themselves. That way, he or she will be better equipped to capture the kind of spontaneous, candid image that encapsulates the joy of childhood.

Margo van der Vooren used this shot of her two children, Mick and Sabine, shouting "Yes, 2000!!", as a New Year image for Millennium Year. The children inscribed the same words, in their own handwriting, on the cards the family sent out. The plain white background allowed van der Vooren to indulge in a little manipulation: she preferred her son's expression in one shot and her daughter's in another, so she simply cut the negatives up with scissors, matched the two halves and made a composite print from them.

Hasselblad, 120mm lens, Kodak Plus-X. Two softboxes for main lighting plus two spotlights on the background.

Wanting to get away from the studio and to try something more spontaneous, Ronnie Bennett invested in an autofocus SLR with a zoom lens. She shot these two children running towards her from the top of a sloping field, and shooting uphill allowed her to fill the frame with the texture of the grass. Because she wanted a 'timeless' image, she chose not to focus sharply on the children's faces and, for the same reason, sepia toned the print.

Canon EOS 50E camera, zoom lens, Kodak Tri-X.

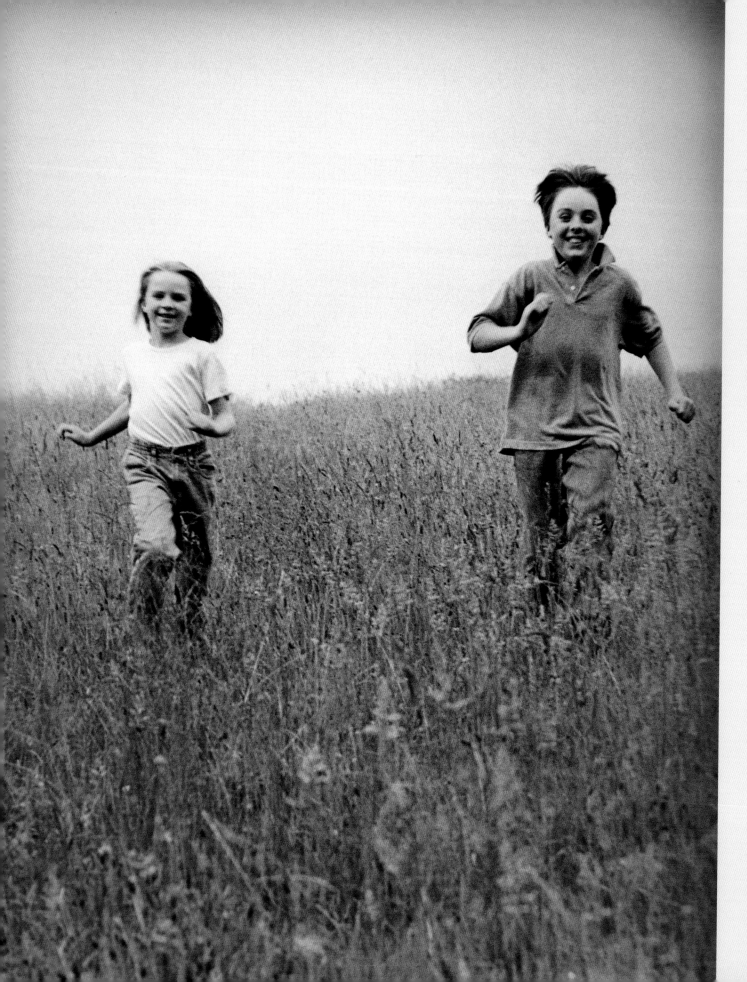

When they come for a studio portrait session, most families want a mixed selection of photographs from which they can choose their favourites, according to Vibeke Dahl. She only ever photographs adults together with their children, either as part of a family group or in individual combinations. Here, the pictures the families liked best included these father-daughter and father-son portraits.

"My clients prefer a casual and natural look, and I actively discourage formal wear, with suits and ties, as I find people look wooden and unnatural in them," says Dahl. "The most important thing is to get the composition right. I try to create the impression that the subjects have just sat down casually that way by themselves."

Vibeke Dahl chose to do a full-length shot of this father and daughter as she felt they both looked good in light-coloured, casual clothes against the grey Colorama background. She lit the picture using her normal studio set-up: a large, 75cm x100cm softbox placed to the left of the subjects and angled slightly downwards, with the white walls of the studio acting as reflectors.

Bronica ETRS, 150mm lens, Agfapan APX 100. Lit by Hensel Monoblock 800 used with Bowens Wafer softbox, at an aperture of f/11.

The casual look is the essence of family photography for Vibeke Dahl, and she tries to pose her subjects in a relaxed way that suggests they have simply sat down that way by themselves. This father-son portrait was another that lent itself well to the full-length treatment, rather than a head-and-shoulders close-up, on account of the co-ordinated textures of their denim outfits.

Bronica ETRS, 150mm lens, Agfapan APX 100. Lit by Hensel Monoblock 800 used with Bowens Wafer softbox, at an aperture of f/11.

The first task with two-year-old Connor, as with all Gerry Coe's young subjects, was to make him feel comfortable in unfamiliar surroundings. Coe encourages children to wander around the studio and examine the photographs on the walls, while also trying to get them used to his own presence. "Sometimes I ignore them for a while at first, I don't talk to them at all. I might say a quick hello and see what the reaction's like – sometimes they look at you very suspiciously," he says. "You have to play it quietly. Let them see the studio and the lights – you tell them the white background is snow, for example, and the lights are magic because you can blow them out. That's usually good for the first three rolls."

Bronica SQA, 80mm lens, Agfa APX 100 developed in Rodinal and printed on Kentmere Document Art paper. Two Wafer softboxes for the main subject lighting, with two lights on the background.

Black-and-white is something of a trademark of Gerry Coe's work. "I was the first person in Northern Ireland to go into black-and-white properly, and the only one who does it in the traditional way, using dish-processing methods to produce a fine art print," says the Belfast-based photographer. "Most other people offering black-and-white do it through the C-41 colour process, which just doesn't look the same. Done properly, black-and-white is out on its own."

Ninety per cent of Coe's work is with children, and his reputation attracts clients from far and wide. The look he creates is clean and natural – children shot against a plain studio background, with no backdrops, no pot plants, seldom any props. "I got rid of all those things years ago," he says. "I don't like using colour either, because for me colour distracts. I might sometimes use it for specific things, such as a graduation picture, but normally I'd advise clients wanting colour portraits to try elsewhere."

Coe's aim always is to capture the personality of the child. For him to succeed, however, the child must be made to feel comfortable in the unfamiliar environment of the studio. "A shoot always starts off very simply," he explains. "My whole idea with a sitting is not to have the kids in a fixed position. They can be sitting or standing or whatever, but generally after a little while they start to relax and do their own thing. They can crawl around the floor, or jump and run around, or react to what I do – that's when their personalities start to come out."

"If you don't like kids and don't have a lot of patience, don't even think of taking this on as a business."

Gerry Coe

Each of Gerry Coe's sessions averages about an hour, although he might spend 45 minutes trying to put a shy or unhappy child at their ease before taking any pictures. Once the session is under way, patience is the watchword. "You have to be massively patient," says Coe. "If you don't like kids and don't have a lot of patience, don't even think of taking this on as a business."

Along with patience comes the need for variety. "A lot of photographers tend to forget that film is cheap," says Coe. "Shooting one roll is not enough – it's too restricted a package. At a sitting I will take at least five or six rolls of a single child and between eight and twelve rolls of a group." Being generous with the raw materials should ensure a better range of pictures to show parents – and that, of course, means better prospects of sales.

To ensure consistent results, Coe keeps his equipment simple. Most of the time he shoots on a Bronica SQA camera with a standard 80mm lens, although his 'pencil portraits' are done on a Mamiya C330 twin lens reflex. He occasionally also uses a 35mm Contax, with a zoom lens and a motordrive, for grainy, informal shots. His usual choice of film is Agfa APX 100, although he also uses Kodak Tmax 100 and Fuji Neopan 400. All his negatives are developed in Agfa Rodinal, printed on Kentmere Document Art paper and matted and framed to archival standards.

There are parallels to be drawn between photographing children and stalking shy wild animals, according to Gerry Coe. Patience means waiting for the right moment to fire the shutter. "It's easy to get a smile out of a child – anyone can do that," he says. "But what you're trying to capture is the moment when they suddenly look up, change their expression, turn their face in a certain way." Connor was a co-operative subject and was fairly relaxed throughout the session. A few simple props helped to absorb his attention and make him less self-conscious in front of the camera.

Bronica SQA, 80mm lens, Agfa APX 100 developed in Rodinal and printed on Kentmere Document Art paper. Two Wafer softboxes for the main subject lighting, two lights on the white background and a small hair light.

Simplicity is the key to Gerry Coe's sessions. He asks parents to bring two or three changes of clothes, and improvises from there. He has no objection to parents remaining in the studio during the shoot – but he diplomatically discourages them from interfering. As well as offering individual prints, Coe sometimes prints a number of different images onto a single 24x20in sheet of paper to create a montage of the session. It's a painstaking job – all the images are exposed individually; none are stuck on. "You don't know until you develop the sheet whether you've made a mistake," says Coe. "It's soul-destroying if you have."

Bronica SQA, 80mm lens, Agfa APX 100 developed in Rodinal and printed on Kentmere Document Art paper. Two Wafer softboxes for the main subject lighting, two lights on the white background and a small hair light.

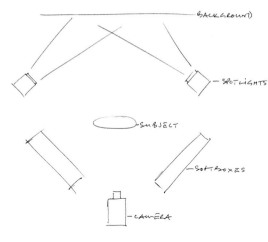

Gerry Coe's sessions are very spontaneous. Although he's happy to talk to parents beforehand, he doesn't lay down any hard and fast rules about what he is going to do. "I just tell people to bring two or three changes of clothes, keep it simple, and we'll take it from there," he explains. "For my own satisfaction, I don't want to feel that I'm doing the same thing every time and getting myself into a rut. I want the children to be fresh to me when they come in and I want to feel that I'm drawing something out of them."

He has no objection to parents being present during the session itself, especially if it helps to relax the children, but he doesn't encourage interference. "Sometimes parents are happy to leave the room once the child's settled down," says Coe. "If they stay, I don't necessarily demand that they keep quiet, but I might ask them to pipe down if the child's looking at them all the time instead of me. I've got a fairly long fuse, but if anyone's too pushy, I'll cut them off eventually. However, you do need to be diplomatic – they are the clients, after all. I'd only shout at people I know reasonably well!"

Some older children and teenagers are so self-conscious that it's hard to get them to co-operate, while others are so thrilled by the whole experience that they virtually direct the session themselves. Ronnie Bennett was lucky with this trio of siblings. The girl lived in the UK with her mother, who commissioned the session, while the two boys lived abroad with their father, and the three hadn't seen each other for several years.

"The boys had just arrived from Australia shortly before the session, and they were incredibly excited to see one another," recalls Bennett. "It was a wonderful session because they all acted like young puppies, larking and tumbling around. I just kept firing the shutter as they got on with expressing how they felt."

For this session Ronnie Bennett had little to do in the way of directing: the three siblings were so excited at seeing each other after a long absence that they were literally bouncing around, full of fun and happiness. All she had to was keep firing the shutter. Lighting came from three Multiblitz Monolights, two on the white background and a third mounted on a boom arm above their heads.

Bronica ETR-SI, 150mm lens, Kodak Tri-X. Lit with three Multiblitz Monolights, two on the background, one overhead.

A shoot needn't take place during a single day: if the photographer knows the child well, he or she can build up a relationship over time, taking advantage of different occasions to create a portfolio of different looks and moods. Ed Krebs took many pictures of his next-door neighbours' son Perry over a number of years. The relationship worked both ways: Krebs could try out new photographic ideas on a willing subject, while the family accumulated an archive of professionally executed portraits of their child.

"Whenever I bought a new camera or lens, or wanted to try out a new lighting idea or backdrop, I would ask Perry to pose for me," says Krebs. "He was animated and inquisitive, and he usually had his own ideas about how he should be photographed, running off to find props. I normally had to compromise, shooting half the session the way I wanted to do it, half using his ideas."

Ed Krebs shot this pensive study in shaded natural daylight, towards sunset, using his favourite Rolleiflex twin lens reflex camera. He gave it a soft-focus effect by placing a diffusion filter under the enlarger lens during printing. "I prefer adding the diffusion at the printing stage rather than putting it on the camera lens," he explains. "This lets you control the amount of diffusion. If you put it on the camera lens, you can't change your mind later."

Rolleiflex TLR, Fuji Neopan 400 developed in PMK Pyro, natural evening light.

A pair of boxing gloves proved an effective prop for this shot. Ed Krebs used a similar lighting set-up to the main picture, except that this time he bounced a single Monolight flash head off a studio umbrella, with an aperture setting of f/16.

Rolleiflex TLR, Fuji Neopan 400 developed in PMK Pyro.

For this shot of his next-door neighbours' son, Ed Krebs used a plain dark background and lit the picture with a single Monolight flash head fired through a softbox, at a setting of f/16. The boy had particularly expressive eyes, and Krebs got in close to emphasise this feature.

Mamiya 645, 150mm lens, Fuji Neopan 400 developed in PMK Pyro.

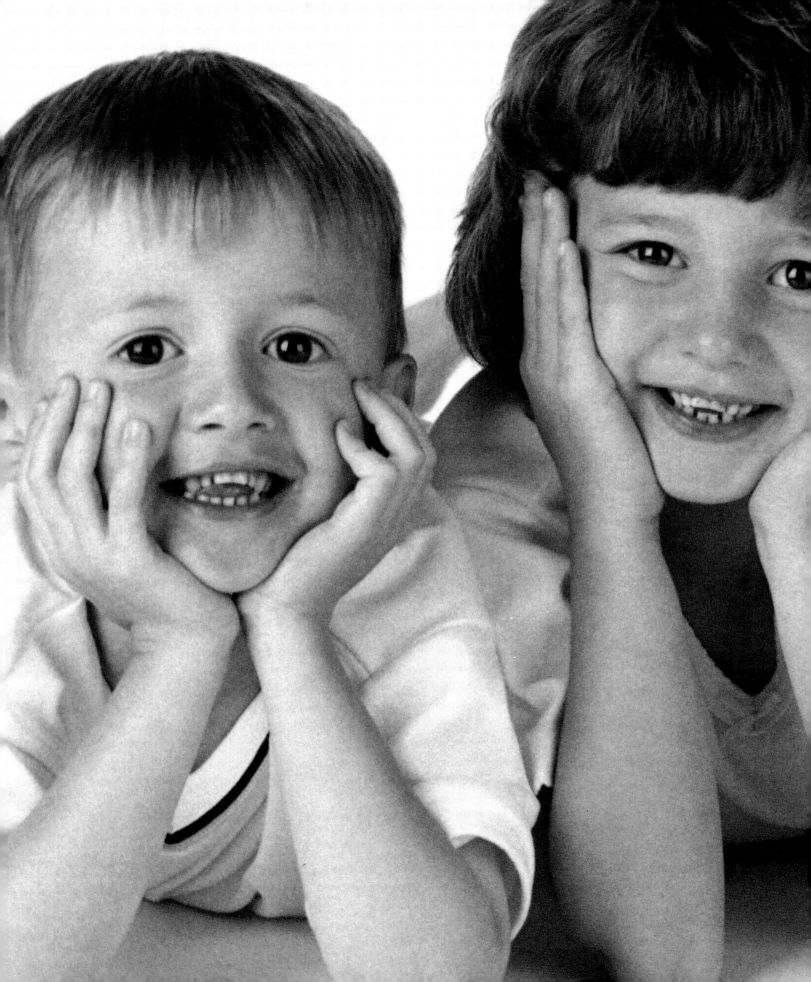

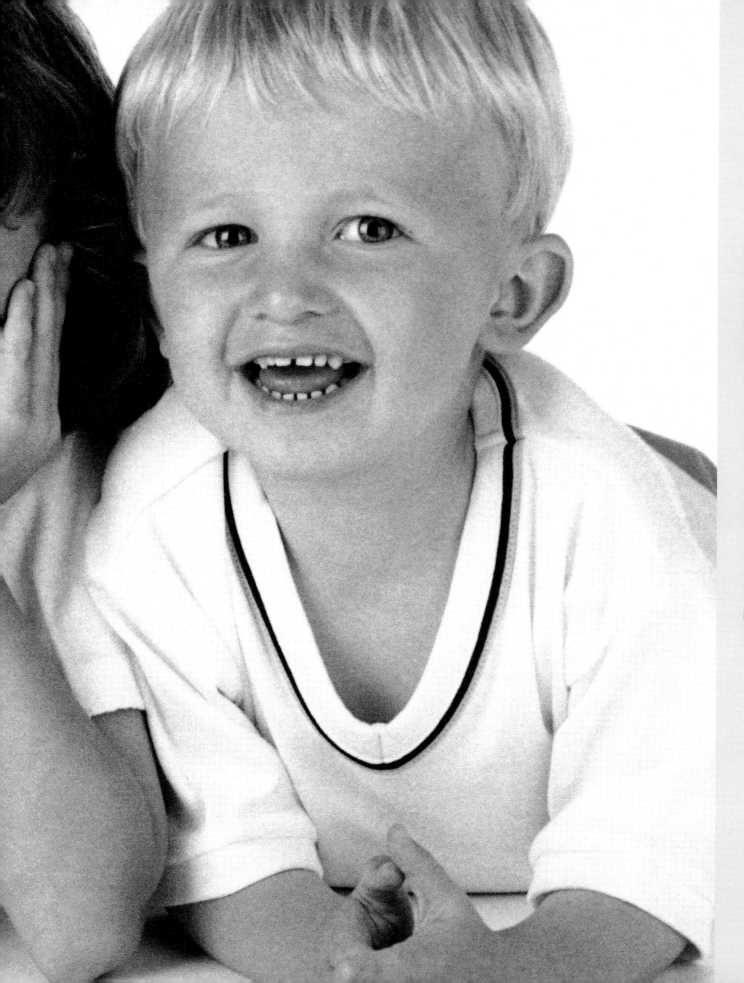

Ed Krebs photographed this young swimmer at her local swimming club, with the towel doing double duty as a prop and as a frame for the subject 's face. The lighting was harsh, with awkward reflections bouncing off the water and concrete, but Krebs sought out a patch of shade for this candid portrait.

Mamiya 645, 150mm lens, Fuji Neopan 400 developed in PMK Pyro. Exposure 1/60sec at f/5.6.

Baseball is a slow-moving game so Ed Krebs has plenty of time to compose his shots. Out on the pitch the light is often harsh and direct, with the children's caps casting dark shadows across their faces, but in the dug-outs it is usually softer, filtering in from one side. Krebs uses a handheld meter to work out his exposures, generally working in the region of 1/60sec at f/5.6

Rolleiflex TLR camera, 75mm lens, Fuji Neopan 400 developed in PMK Pyro. Exposure 1/60sec at f/5.6.

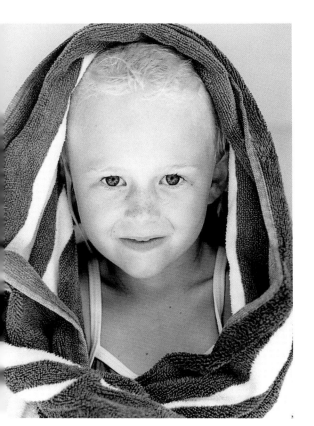

For successful child portraiture, the photographer needs to establish a rapport with the young subject. This may be long-term or it may only last the couple of hours it takes to complete a shoot, but relaxed and comfortable interaction is vital if you are to bring out anything of the child's character.

One good way of engaging with children is to photograph them while absorbed in a favourite hobby or sport. Chess sets, bikes and musical instruments make great props for a studio session. Alternatively, the shoot can take place on location – on the sports field, at the swimming pool or at the adventure playground. Familiar objects put children at their ease and make them feel less self-conscious. Some may even be eager to show off their sporting prowess.

Ed Krebs regularly uses sports and hobbies as a context for his portraits. Two long-running projects in particular have yielded many successful pictures: every summer he shoots candid portraits for a local swimming club in Laguna Beach, California, while for the past 12 years he has also been photographing Little League baseball. "I go to games seven days a week for about three months every spring, all at the same ballpark," he explains. "Because I go so often, the kids get used to me being there and reveal their true faces to the camera, even when they're having a bad day."

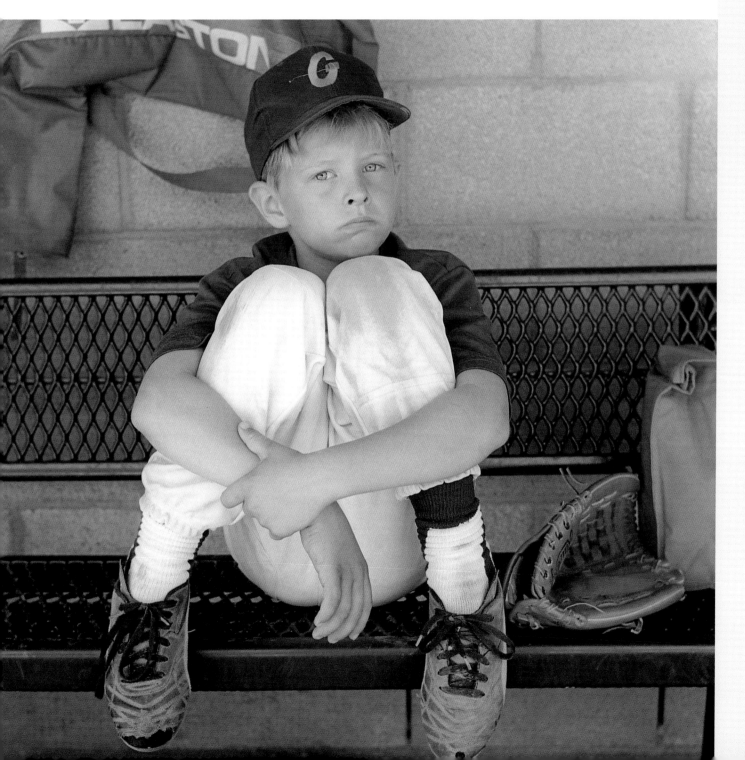

"For me photographs are all about eye contact – you can't get a good picture without it," says Gerry Coe. "That's why you never, ever look through the camera when you're trying to take a child's portrait. All they can relate to is the top of your head, and they'll put on a silly grin because they think that's what's right for the camera. You're always, always working with the eyes: it's the only way of getting the expression."

Coe sets his camera up on a tripod and then moves around it, talking and engaging with the subject all the time so that they follow him with their eyes, and firing the shutter with a remote release. For a portrait involving direct eye contact with the camera, he positions himself fractionally to one side of it. For variations in which the child is looking up, or slightly to one side, he moves around the room, ensuring that he still has the child's attention.

"You can't work properly without a tripod," he says. "You can get grab shots but I don't think you're interacting strongly enough with the child. You have to have the camera set so you can play around and interact with them."

Having the camera fixed in position on a tripod allows Gerry Coe to interact with his subjects and to maintain eye contact. Once he has their attention, children tend to follow him around the room with their eyes, allowing him to control the direction of their gaze from shot to shot.

Mamiya C330, 135mm lens, Agfa APX 100 developed in Rodinal and printed on Kentmere Document Art paper. Lit by two Wafer softboxes, one either side of the subject, with a reflector beneath the face.

Babies' eyes are very large in proportion to the rest of their faces, and shooting in close-up helps to accentuate this appealing characteristic. The high-key effect is an example of what Gerry Coe calls his 'pencil portraits' – for more on these, see chapter 9.

Mamiya C330, 135mm lens, Agfa APX 100 developed in Rodinal and printed on Kentmere Document Art paper. Lit by two Wafer softboxes, one either side of the subject, with a reflector beneath the face.

A photographic session should be as much fun as possible. Relaxed and happy children photograph better than tense and nervous ones – and the last thing you want is for them to feel that the experience is an ordeal. The key to Gerry Coe's photography is spontaneity. Rather than trying to direct his subjects, he lets them run around the studio, laugh, play and be themselves. He jollies them along with jokes, stories, silly noises – and he might even pretend that the camera is a chicken. He never orders them to sit still and smile.

Children respond more readily to this approach than to being asked to 'watch the birdie' or to laugh at the antics of a glove puppet, but the method demands a lot of patience and the photographer has to be alert to capture fleeting poses and expressions. Coe maximises his chances by using a lighting set-up that gives an even coverage over most of the studio area: two softboxes of equal strength, one either side of the child, with sometimes an additional hair light to pick up detail, and two lights aimed at the continuous paper roll that forms the white background. The subject is, in effect, surrounded with light.

"I really don't like the organised approach to portraiture, with set styles and stiff poses, furry rugs, plants or make-believe backgrounds," he says. "When a child comes into the studio it's a case of 'Let's see what happens'. Every sitting is different and that's what parents want – life, vitality and personality. They want to be able to say, 'That's my child'."

If you're not prepared, you risk missing out on the spontaneous shots that are often the most 'real'. This little chap was running around all over the studio until, just for a moment, he hunkered down in front of the camera and peered curiously into the lens. Gerry Coe snatched a quick grab shot which turned out to be one of the best of the session.

Bronica SQA, 80mm lens, Agfa APX 100 developed in Rodinal and printed on Kentmere Document Art paper. Two Wafer softboxes for the main subject lighting, two lights on the white background and a small hair light.

"Every sitting is different and that's what parents want – life, vitality and personality."

Gerry Coe

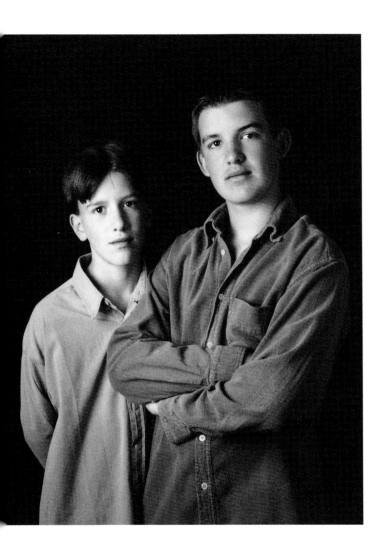

When photographing two children together (most commonly siblings or cousins), the most important factor is their positioning, according to Gerry Coe. To some extent this depends on the age of the subjects: younger children can sit on the ground or roll around, while older ones look better standing side by side.

Coe steers clear of stiff poses, especially with younger children. "I set them down roughly in the right position and then as things progress, encourage them to squeeze together, or hug, just so that they start laughing and having fun," he says. "If they start doing things on their own, looking at each other and having a giggle, that's lovely too. I just let them improvise."

Two children can be twice as much work as one, as you have two expressions to get right. "It's just making sure they fit together, without it looking posed," says Coe. "And you have to get both of them looking at you with the same – or similar – expression. You can't have one looking serious and the other laughing their head off."

With older children, a dark background sometimes works better. Gerry Coe used one to create a more 'manly' atmosphere for these teenage brothers. "A white background would have been all right for a full-length shot, but for teenage boys you don't really want a light, airy photograph," says Coe. "I did a series of different shots of these two, all very casual. They were one-eighth Sioux Indian, and the way the older one stood with his arms folded he looked a bit like an Indian brave."

Bronica SQA, 80mm lens, Agfa APX 100 developed in Rodinal and printed on Kentmere Document Art paper. Lit by one Wafer softbox to the left, a second further back on the right acting as a fill and a small hair light.

This session began as a set of Communion photographs of the older sister. Gerry Coe then photographed the two girls together in various configurations, standing full-length, sitting on the ground and running around. He finished the session with this double pencil portrait.

Mamiya C330, 135mm lens, Agfa APX 100 developed in Rodinal and printed on Kentmere Document Art paper. Lit by two Wafer softboxes, one either side of the subjects, with a reflector beneath their faces.

The more children there are in a group, the more difficult it is to get them all looking interested and facing in the right direction at the same time. "You're art directing all the time, trying to keep their interest, keep it moving," says Gerry Coe. "You can't hang around or the kids will get bored."

Pictures sometimes end up virtually falling together. Coe starts by arranging the group into some semblance of order, with arms and legs in vaguely the right places, but then lets the children get on with it. He might encourage them to squeeze together or hug each other, but a lot of it is improvised.

Typically, he uses a whole roll of 12 shots on one set-up and then changes the positioning of the group when he changes film. This gives a good variety of pictures to choose from. "My average is five rolls of film for a single child, seven for two or three kids and nine or ten for larger groups," says Coe. "The parents will see all the portraits, apart from blinks and obvious out-takes. I don't feel it's my right to select which ones to show them. They know their kids better than I do."

With groups, Gerry Coe tries a number of different arrangements over the course of a session and typically uses a whole roll of film on a single set-up. For groups of two or three he usually goes through seven rolls. He shows the parents all the pictures from the session, leaving the choice of enlargements up to them.

Bronica SQA, 80mm lens, Agfa APX 100 developed in Rodinal and printed on Kentmere Document Art paper. Two Wafer softboxes for the main subject lighting, two lights on the white background.

"You let things happen," says Gerry Coe. "If you put kids into position and tell them not to move, you don't get any life." This shot summed up the different personalities of the three young sisters: the eldest child, on the left, was rather serious, the baby was alert and curious and the child on the right was a live wire who thought being photographed was great fun.

Bronica SQA, 80mm lens, Agfa APX 100 developed in Rodinal and printed on Kentmere Document Art paper. Two Wafer softboxes for the main subject lighting, two lights on the white background.

It's essential to make the configuration of the group appear natural. Gerry Coe tries out a number of different combinations until he feels satisfied that he's found the right 'fit'.

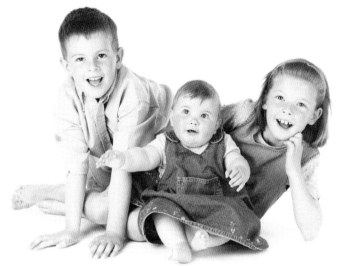

Obviously the more children there are, the more complex the equation becomes. "You're trying to get them into a position that looks natural," says Gerry Coe. "You might have one child sitting on a box at the back to give them a bit of height, then two or three coming in at the sides and perhaps the youngest one lying across the front – that gives you a good base."

Sometimes he asks the eldest child – especially if it's a boy – to lie on the floor and then gets the younger ones to pile on top of him. The younger ones think this is great fun, while the grimaces of the 'victim' can also make great pictures.

Sometimes Coe goes for a more pensive group study, but it's not unusual for one of the younger children to get the giggles while the others are staring reflectively into the lens. "You want the whole range," he says. "You want quiet, you want serious, you want laughing, you want frantic – you want everything."

Large groups need careful arrangement if the picture is not to appear messy. Having one child, usually the youngest, lie down at the front provides a good base, while others can be brought in at the sides. The idea is to make the composition appear as balanced as possible.

Bronica SQA, 80mm lens, Agfa APX 100 developed in Rodinal and printed on Kentmere Document Art paper. Two Wafer softboxes for the main subject lighting, two lights on the white background.

"You want the whole range," says Gerry Coe. "You want quiet, you want serious, you want laughing, you want frantic." He caught this family group sharing an unrestrained moment of fun.

Bronica SQA, 80mm lens, Agfa APX 100 developed in Rodinal and printed on Kentmere Document Art paper. Two Wafer softboxes for the main subject lighting, two lights on the white background.

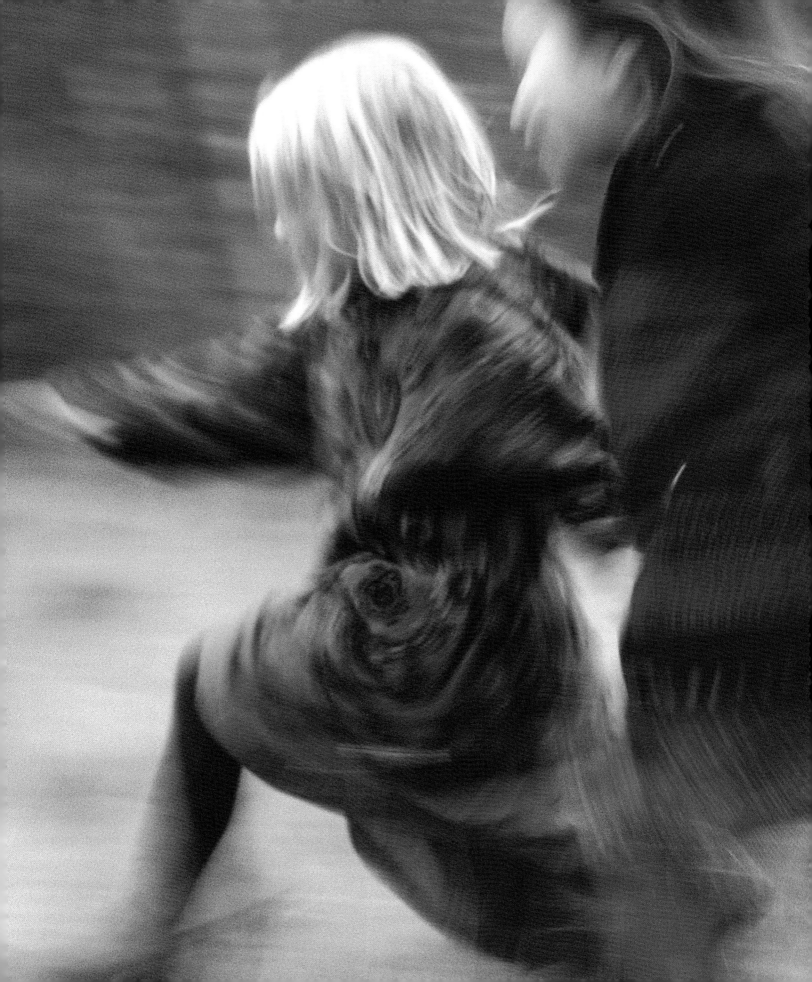

Shooting pictures for a business client, Richard Bailey wanted to portray the happiness and innocence of childhood. His subject entered willingly into the spirit of the project, dressing up in a fairy outfit that made her feel special. A bunch of twigs provided a simple yet effective prop.

Mamiya RB67, 180mm lens, Kodak Ektachrome 100 cross-processed, lit by single softbox.

A black-and-white variation. Children love playing games of make-believe and in many cases art directing simply means encouraging them to pretend. "When taking photographs of kids in the studio, unless they are seasoned professional models, the best thing to do is to keep it fun," says Richard Bailey.

Mamiya RB67, 180mm lens, Ilford FP4, lit by a single softbox.

Richard Bailey placed his subject in front of a black velvet background. The lighting came from a single Bowens Prolite flash head, placed to the left of the camera and fired through a softbox. "Use a lot of film, but remember that a child's attention span is pretty short," advises Bailey.

Mamiya RB67, 180mm lens, Kodak Ektachrome 100 cross-processed, lit by softbox to left of camera.

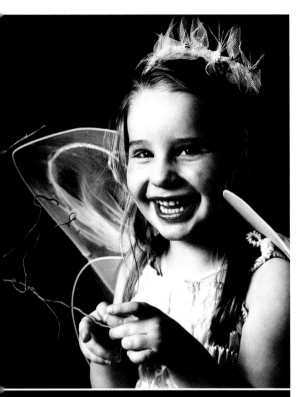

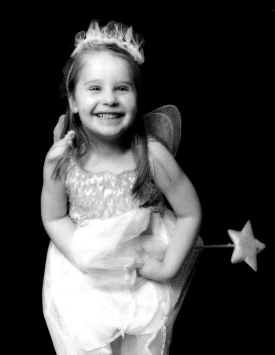

A lot can be learned from the techniques of editorial and advertising photographers. Shooting to a brief, they invariably work with a very particular look in mind. More often than not, to deliver the pictures their clients want, they must create that look themselves. This is where styling and art directing come in.

There is no mystery involved in styling or art directing, nor are they rigid disciplines. They simply mean visualising the way the picture should look beforehand and then using the appropriate clothes and props to realise it, together with the lighting and backgrounds to create the right atmosphere. Children shouldn't be forced into the role of supermodel: rather they should be encouraged to treat the whole thing as a game. Most children love games of make-believe and dressing up, and the more relaxed and happy they are, the better the results are likely to be.

Commissioned by a design group to produce pictures for its annual report, Richard Bailey photographed this little girl in a fairy costume against a plain black velvet backdrop, using a single softbox for lighting. The pictures were destined for commercial use, but any parent would be delighted with a set of portraits like these.

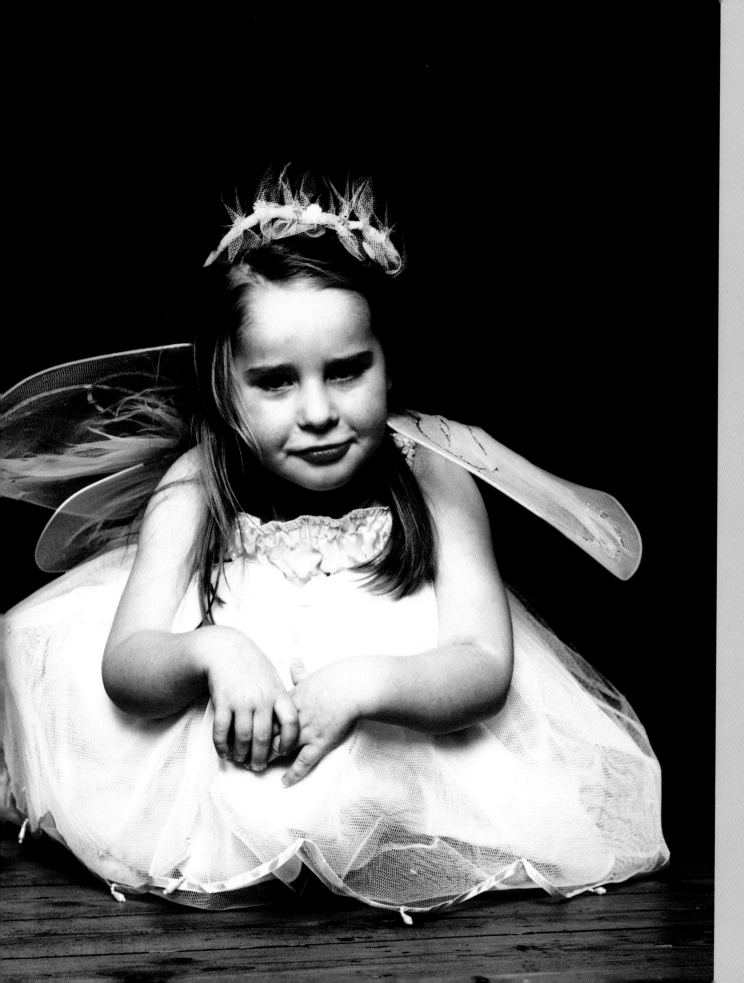

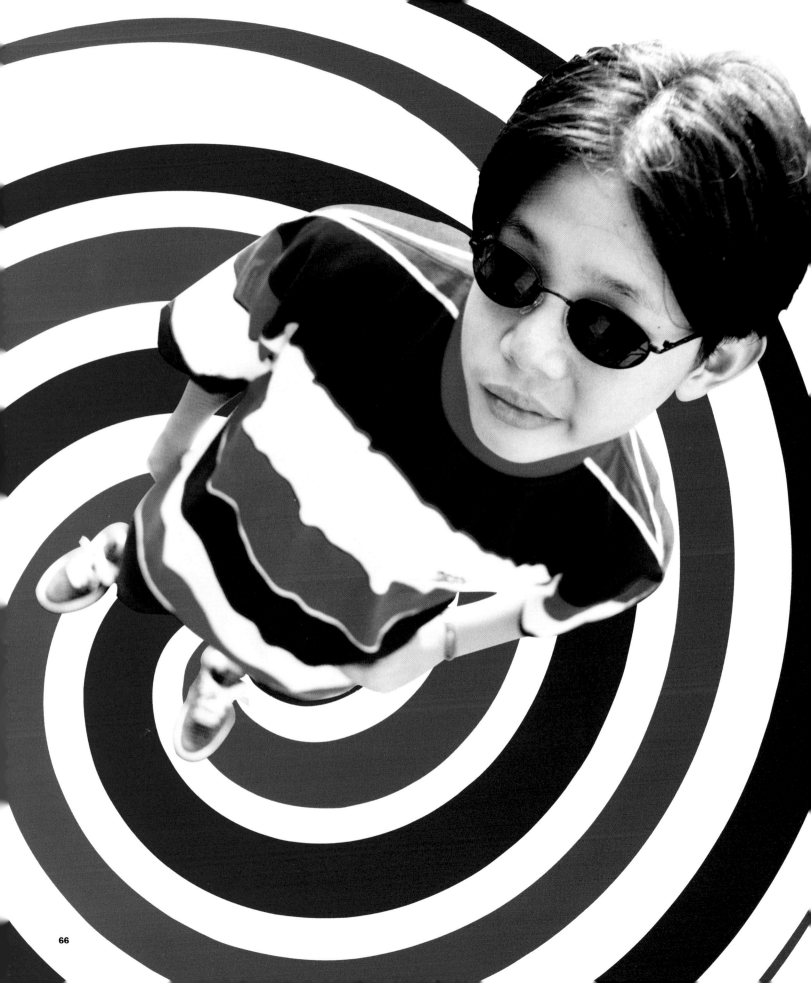

Spontaneity is important when shooting kids, but that doesn't mean you should neglect the planning. It's essential to visualise how the finished picture will look, and what it will be used for. In these two pictures by Thaddeus Harden, backgrounds played an important role. In one, taken for an editorial assignment, the background was conspicuous by its absence. In the other, the photographer used a neutral background that could be replaced later by one of his own devising.

Thaddeus Harden shot this boy acting cool from a high vantage point, inside a white dome used for concerts in Central Park in New York. The boy was backlit by strong sunlight but the building's white walls acted as a giant reflector, bouncing light back onto his face. Harden later scanned the image and used Adobe Illustrator software to create the spiral background, matching the colours to those of the boy's t-shirt. He has used the image as stock and for promotional purposes.

Hasselblad camera, 40mm Distagon lens, Kodak Ektachrome 100VS. Backlit by natural sunlight, with white wall acting as reflector. Spiral background created in Adobe Illustrator.

Commissioned by a publisher to take a series of shots for a children's science book, Thaddeus Harden asked his young subjects to imagine they were butterflies. The pictures would later be superimposed, to scale, onto pictures of the insects in the wild. Harden diffused the flash light though a metal mesh 'scrim' attachment and used a plain, seamless white paper backdrop so that the images could be cut out cleanly. A graphic artist later added wings and antennae to the portraits.

Nikon SLR camera, 50mm lens, Kodak Ektachrome 100VS with flash, white background.

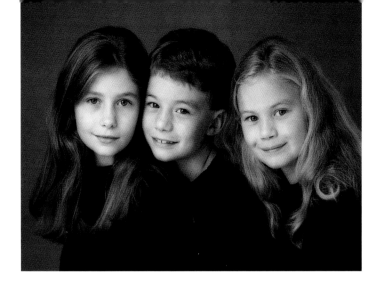

Vibeke Dahl uses her medium format camera very much like a 35mm SLR, shooting handheld and continually re-assessing the composition of the shot through the viewfinder. This gives her a lot of flexibility, but she still has to ensure that her subjects are in the right place in relation to the lighting set-up and background and, where more than one child is involved, in relation to one another.

She usually starts by shooting close-up portraits of the child in a seated position. This ensures that she has at least something to show the parents and also helps to 'warm up' the subject, encouraging more natural facial expressions and body language. Only then does she attempt full-length or action portraits.

"Often children feel awkward at the beginning of a session; they feel vulnerable standing against the background on their own, with everyone looking at them," says Dahl. "The exceptions to this rule are the hyperactive ones who are best caught in the first five minutes, before they grow too confident and run riot. And it's not a good idea to do full-length walking shots of the under-fours unless you've worked out a plan for trapping them in one place."

For close-up shots of family groups Vibeke Dahl gets her subjects to sit on adjustable office stools, which can be moved up or down to ensure that their heads are aligned. Usually the smallest child is placed at the front, the bigger ones behind. She dressed these three siblings in dark clothing to concentrate attention on their faces and got them to sit close together. "It's important to keep reassuring children that they are doing the right thing as they can feel awkward sitting this way and, before you know it, they move apart," explains Dahl. "I always take a selection of pictures, showing serious expressions, smiles and half-smiles. The biggest challenge with three children is to get their expressions synchronised, with their heads also at a natural-looking angle."

Bronica ETRS, 150mm lens, Agfapan APX 100. Lit by a single Bowens Wafer softbox at f/11.

Vibeke Dahl got the two boys to stand still and very close together, the younger one nearer the light and his older brother with his hand in his pocket. When everything looked right through the viewfinder, she got them to look at each other and laugh on the count of three. She repeated this a few times to make sure that she got a useable result.

Bronica ETRS, 150mm lens, Agfapan APX 100. Lit by a single Bowens Wafer softbox at f/11.

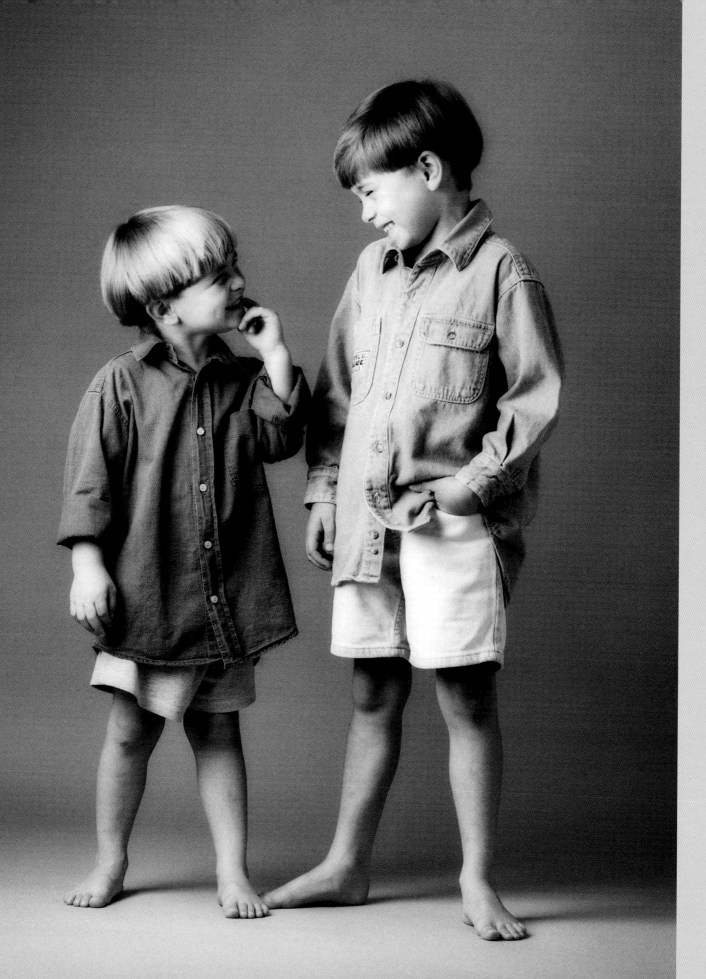

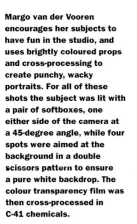

Margo van der Vooren encourages her subjects to have fun in the studio, and uses brightly coloured props and cross-processing to create punchy, wacky portraits. For all of these shots the subject was lit with a pair of softboxes, one either side of the camera at a 45-degree angle, while four spots were aimed at the background in a double scissors pattern to ensure a pure white backdrop. The colour transparency film was then cross-processed in C-41 chemicals.

Hasselblad camera, 150mm lens, Kodak Ektachrome 100 Plus cross-processed in C-41 chemicals. Exposure 1/60sec at f/11.

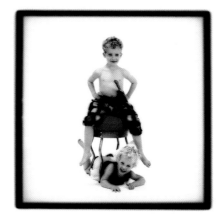

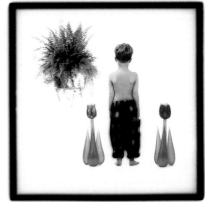

"Children are easier to photograph than adults because adults are more afraid of looking silly."

Margo van der Vooren

"If a child feels good in your studio, it will do anything you want," says Margo van der Vooren. "I always ask parents to bring along the kids' favourite toys or the 'best friend' they sleep with, so that they feel secure and won't be frightened standing all by themselves in the studio. Grown-ups get nervous having their picture taken, let alone young kids."

Van der Vooren keeps her own stock of props to help put children at their ease, including inflatable plastic flowers, well-known character figures and chairs in which little girls can pretend to be a princess. She deliberately chooses colourful objects and often enhances the colours through cross-processing. "Most of these pictures I did for fun," she says. "I'm always trying to think of new things to do and whether or not they are marketable. Sometimes I do things just for my portfolio or simply because I can't sleep at night."

To break the ice with the children, she makes funny noises or gets them to pull funny faces or play hide and seek. She might put on a tape of their favourite music, and then the session begins to resemble a party. "You can make kids dance, shout, stand up, sit down, anything. Getting them to make an angry face can be fun – especially if their mother has told them to smile for the camera," she says. "On reflection, children are easier to photograph than adults because adults are more afraid of looking silly."

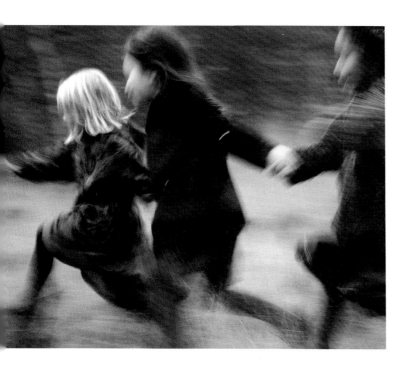

Stepping outside the confines of the studio doesn't mean that you relinquish control over the way the picture looks. Different locations, together with changing seasons and weather conditions, can be used to create an infinite variety of moods. Tony Hopewell is a fashion and advertising photographer who regularly works with children and helps to create advertising campaigns for some of the biggest names in fashion. The fashion-led lifestyle look is always popular with parents – and the techniques he uses are applicable to children's photography in general.

"Advertising and fashion photography is a team game and when working with kids it's very important to have the right people around you – assistants, stylists, hair and make-up artists, even the van driver," says Hopewell. "Everyone needs to know what you are trying to do, especially on location, when the team can be together 18 hours a day for up to three weeks at a time. Onc of the most important parts of the shoot is the casting. Choosing the right kids for the shoot – in terms of temperament, as well as having the right look and being the right size for the clothes – makes the whole thing run much more smoothly."

For this action shot, Tony Hopewell set his autofocus camera to 1/15sec in shutter priority mode, and let the slow shutter speed blur the motion of the girls' arms and legs. He blurred the background too, by panning with the subjects as they ran across the frame.

Nikon F5, 35-70mm lens, Fujichrome Provia 100 rated at ISO 80. Camera set to shutter priority mode at 1/15sec.

These pictures were done on location in Sherwood Forest, near Nottingham, on a test shoot for a range of children's fashion clothing. A long zoom lens used with a wide aperture gave Tony Hopewell an extremely shallow depth of field, while the muted greens and browns of the autumnal foliage provided a neutral backdrop for the bright clothes the girls were wearing.

Nikon F5, 80-200mm lens, Fujichrome Provia 100 rated at ISO 80. Camera set to aperture priority mode at about f/4.

" When working with kids it's very important to have the right people around you – assistants, stylists, hair and make-up artists, even the van driver."

Tony Hopewell

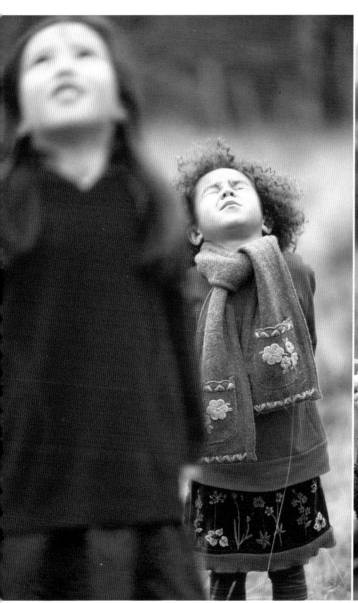

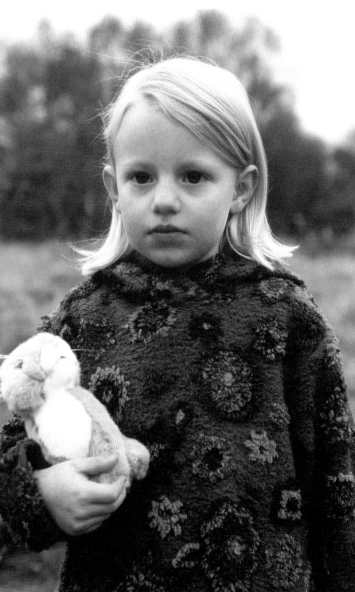

In the UK, spring and summer ranges of children's clothing are photographed in the depths of winter, so that brochures and adverts can be prepared in time for an April launch. For that reason Tony Hopewell often travels to locations such as Sanibel Island, on the Gulf of Mexico coast of Florida. For this shot his autofocus camera wouldn't lock onto the moving subject quickly enough, so he prefocused and let the girl run through the frame. With Provia 100 transparency film rated at ISO 80 ("I find that's its true speed," he says), he used a relatively slow shutter speed to introduce a hint of movement into the girl's feet and the hem of her dress.

Nikon F4, 35-70mm zoom, Fujichrome Provia 100 rated at ISO 80. Shot at about 1/125sec.

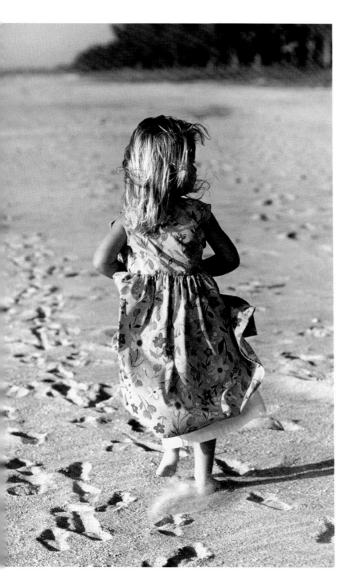

Working outdoors means it's harder to control lighting conditions, although this need not be a problem unless the weather is thoroughly wet and miserable. As Tony Hopewell points out, the technical side of photography has got a lot easier in recent years, particularly if you're using 35mm gear with all its automatic functions. Never be afraid of switching to auto – if it means you've got something less to worry about, take advantage of it!

Even with medium format cameras and hand metering, rapidly changing light conditions are now less of a problem than they used to be, says Hopewell. Newer films are more forgiving and respond more readily to push or pull processing. "The biggest problems come on days when the sun is in and out all the time. I work with an assistant at the subject position, just out of shot, who takes readings with a hand meter and constantly calls out the changes, but it's the variations in colour temperature that cause the problem. You don't have time to keep adding colour correction filters or taking them off."

This was also taken on Sanibel Island, but on a different trip and for a different client. After a swimwear shoot at a private pool, this little girl simply dived in and swam underwater like a fish. Impressed, Tony Hopewell jumped in after her and took three or four frames on an underwater camera. "This shot wasn't planned, but was one of those lucky accidents that the client loved," he says.

Nikonos IV on auto, Fujichrome Provia 100.

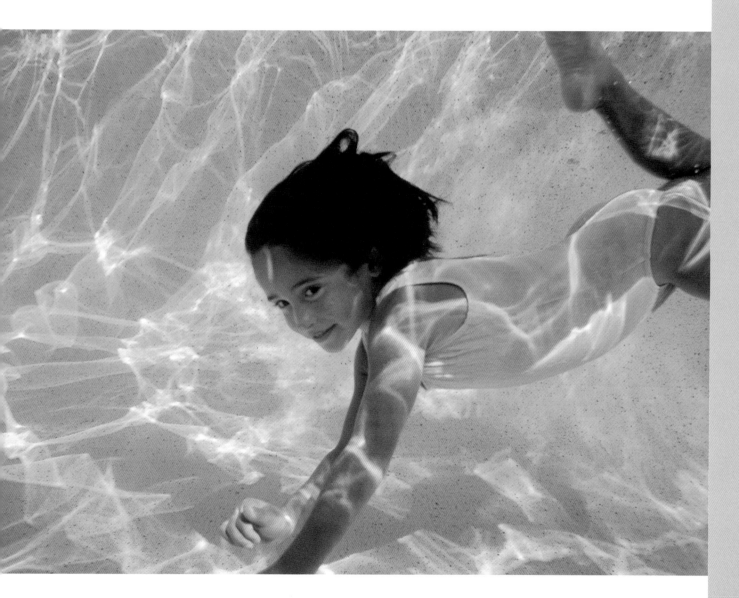

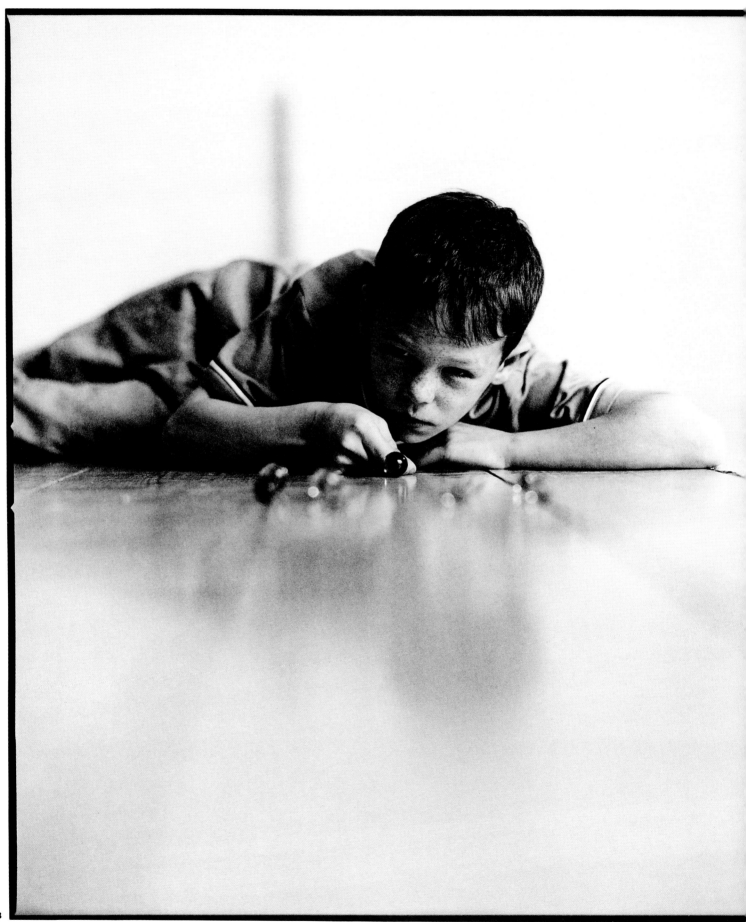

This shot formed part of an ad campaign for a major software company. Tony Hopewell used a daylight studio but augmented the lighting with a 4kw daylight-balanced bulb. He got right down to floor level and opened up the lens to minimise depth of field. The marbles were carefully positioned, using Polaroids to check their level of focus.

Hasselblad 201f, 110mm lens, Kodak Tri-X rated at ISO 320, lith print.

Studio lighting gives you a great degree of control over the way your images look. Set-ups need not be complicated. A couple of flash heads, combined with a softbox, an umbrella and a reflector or two, offer a wide variety of basic options. With experience, more sophisticated set-ups can be used to create bright and punchy studio effects. Or you may prefer simply to work with available window light, which is perfect for creating soft, moody images.

Whatever your approach, remember that children get bored very easily, even when they're working with top professionals. "You have to know what you are trying to do," says advertising photographer Tony Hopewell. "Get the shot set up and Polaroids done using an assistant as stand-in while the hair and make-up artists are working on the child, so that you can get straight into the shot. Even when the child is ready, you have to keep inventing new little twists so that the whole thing stays fun and you keep their attention."

You can't afford to take ages fiddling with lighting set-ups. Get everything in place before the session begins and keep the lighting consistent from shot to shot. This allows you to work quickly and to concentrate on what the subject is doing. It's relatively easy to control the lighting – it's less easy to control a bored and fractious child.

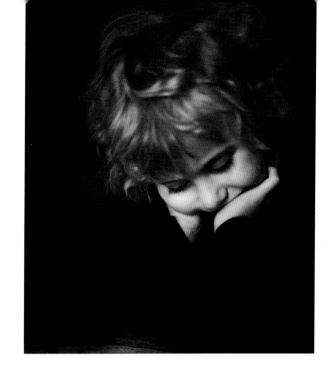

Dark clothing and a dark backdrop ensured that only the girl's face and hands showed up. Low light levels meant that Richard Bailey was working with very slow shutter speeds, so a tripod was essential. In some shots, however, a slight blur added to the dreamy feel of the pictures.

Mamiya RB67, 180mm lens, Ilford FP4 and tripod. Exposure 1/15sec at f/4.5.

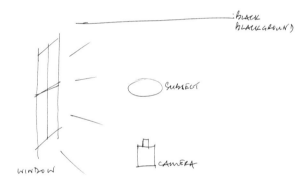

Any room can function as a studio: available light, slanting in through a window or an open door, is a very simple source of illumination but a very effective one. Sometimes window light is soft and gentle; at other times it can be harsh and directional, creating areas of deep shadow and strong contrast.

For these shots Richard Bailey used the light from a single window to illuminate his subject. Dressing the little girl in dark clothes and placing her in front of a dark background meant that only her face and hands were recorded, an effect which enhanced the dreamy, introspective feel that he was trying to achieve. Working in low light levels with quite a fidgety child meant that subject movement was always a possibility. However, in some shots Bailey felt that a slight lack of sharpness only added to the mood.

Mindy Myers likes working with Ilford XP2, a 'chromogenic' black-and-white film that has a wide exposure latitude and is normally developed in C-41 colour chemicals. "It can be processed C-41 to get a sepia look, but you can also make true black-and-white prints if you want," she says. She also likes to work with a shallow depth of field, with her standard lens opened up to its maximum aperture.

Nikon F100, 50mm lens at maximum aperture of f/1.4, Ilford XP2.

These two siblings are the children of friends, and Mindy Myers photographs them about once a year, using her 'portable studio'. "They get very excited and can't wait for their turn in front of the camera," she says. "I just set everything up and chat to them about what they've been doing lately. When they let their guard down, I start shooting." She used natural light from a south-facing glass door, with the subjects seated about 1.5 metres away and a black backdrop set up two metres behind them.

Nikon F100, 50mm lens at maximum aperture of f/1.4, Ilford XP2.

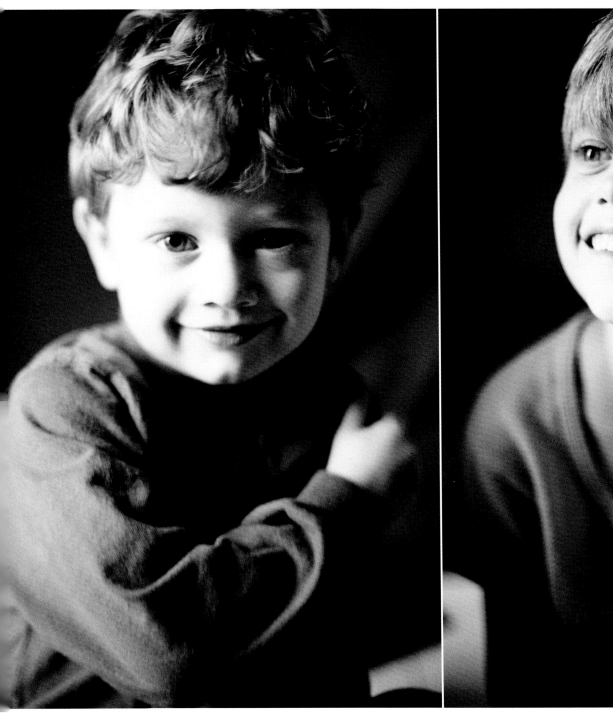
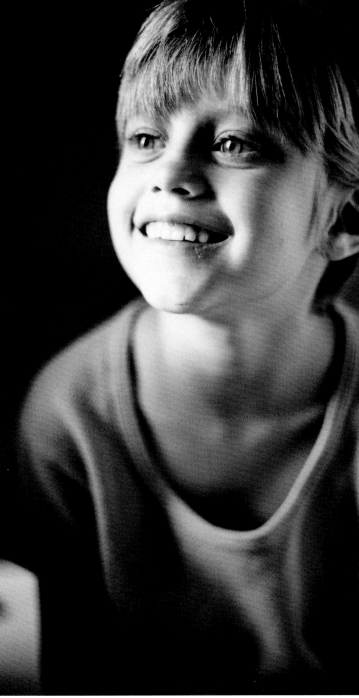

Mindy Myers calls her way of working "natural child photography". She doesn't pose her subjects or coerce them into smiling, she doesn't use elaborate backdrops, props or locations – and she almost always uses natural light. "Natural window light is my preferred lighting," she says. "I enjoy it because I can easily throw a backdrop up at my home or at the child's home. It also eliminates the extra equipment, which I think can be intimidating. I stick with the basics as often as possible."

Her style has a strong documentary flavour to it. To make children feel comfortable, she operates in the domestic environment, working around feeding and nap schedules as required. While taking pictures of older children, she chats to them about their schools, their hobbies and the sort of day they've had, which helps to take their minds off the camera and allows her to capture relaxed, unposed expressions. And she takes her time: she rarely plans to photograph more than two or three children in a single day, to avoid having to hurry any of them through a shoot. "My main intention is to create a photograph of the child that doesn't reflect me in it," she says.

"My main intention is to create a photograph of the child that doesn't reflect me in it."

Mindy Myers

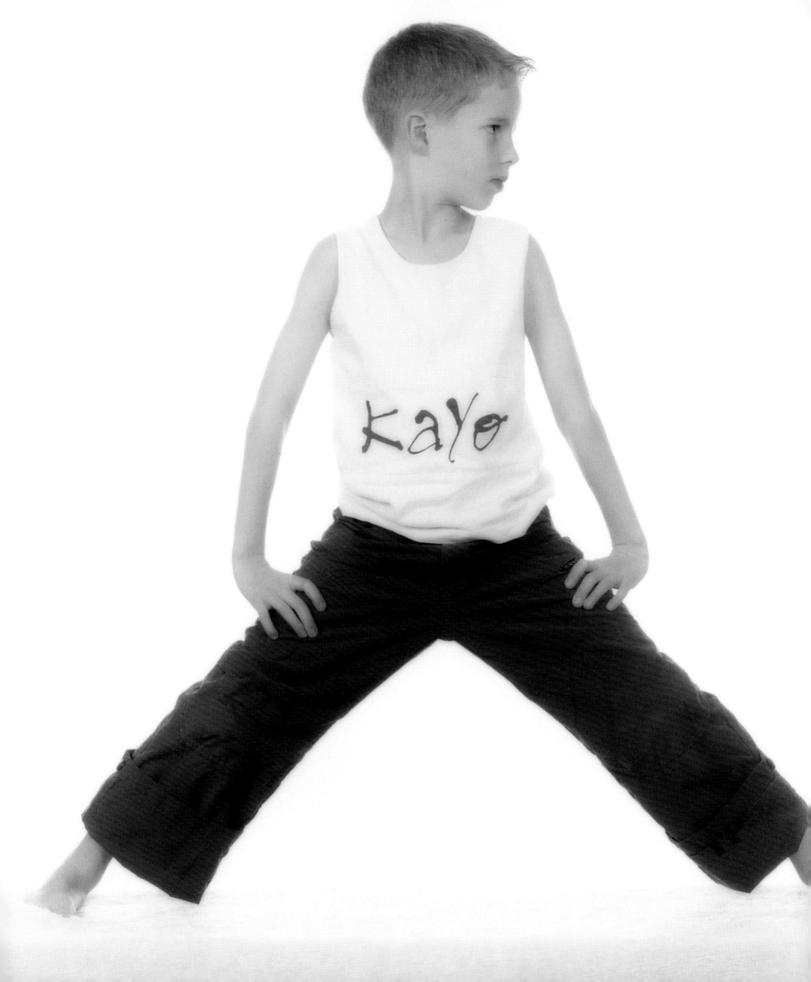

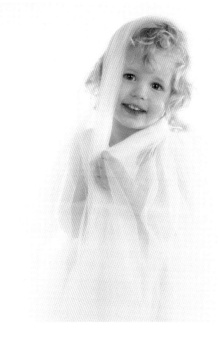

For this shot of her son Mick, Margo van der Vooren used her normal 'high-key' set-up: a white background, two softboxes on the main subject and two spotlights on the background. "The pictures I like best are not usually the ones where the children are laughing," she says. "I do a few smiling pictures in each session because mothers and grandparents love to see their children happy. But for the enlargements I prefer the ones in which the children are looking a little more serious."

Hasselblad, 120mm lens, Kodak Vericolor 160 Pro. Lit with two softboxes, with two spotlights on the background. Exposure 1/60sec at f/11 for the subject, 1/60sec at f/16 for the background.

Margo van der Vooren used the same set-up for this shot of her daughter Sabine, which was used as an advert for a shop selling bridal wear. The combination of softboxes and spotlights gives a very soft, even illumination, bathing the subject in light. Catchlights from the two softboxes can be seen in the little girl's eyes.

Hasselblad, 120mm lens, Kodak Vericolor 160 Pro. Lit with two softboxes, with two spotlights on the background. Exposure 1/60sec at f/11 for the subject, 1/60sec at f/16 for the background.

To create her 'high-key' studio portraits, Margo van der Vooren uses a plain white background and bathes her subjects in soft white light. The main subject lighting is provided by a pair of softboxes, set up one either side of the camera and each pointing towards the subject at an angle of 45 degrees. She also positions a pair of spotlights level with the subject and aimed at the background, to create a soft, even glow.

The subject is placed about four metres in front of the background, to avoid any reflections from behind. To prevent the background becoming too bright, she gives it slightly less exposure than the main subject – perhaps 1/60sec at f/16 as opposed to 1/60sec at f/11.

Van der Vooren used a similar lighting set-up for the cross-processed full-length portraits featured in chapter 5 and elsewhere in this book, except that these had an additional pair of spots placed behind the subject, one to either side and both angled forward at an angle of 45 degrees to meet in a 'scissors' pattern behind the child. This ensured that the floor remained white while the subject was surrounded with light, giving each child their own 'aura'.

The lighting set-up for Margo van der Vooren's high-key portraits. The dotted lines indicate the second pair of spotlights used for her cross-processed studio portraits.

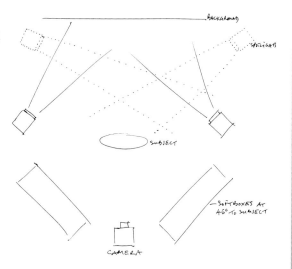

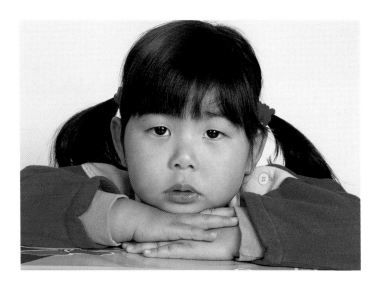

Softboxes and umbrellas provide soft, even lighting and so are perfect for pictures of babies and young children. Angela Hampton employed one of each to good effect here, using the white background to further soften and diffuse the light.

Canon EOS 5, 24-80mm zoom, Fujichrome Sensia 100

Babies and young children usually benefit from soft, even lighting, and this is most commonly achieved by using a softbox or umbrella on a studio flash head. A softbox is basically a large enclosed 'box' with a silvered interior and a white translucent front, through which the light is diffused. Umbrellas come in a variety of types, but white ones provide the softest illumination. Light can be fired through them or bounced back off their inner surface. Both devices can be used singly or in pairs, usually positioned either side of the subject.

They're not compulsory, however: high-contrast lighting effects can also be very effective, as Margo van der Vooren's baby portrait shows. But this is an approach that should be used sparingly: it is difficult to get right and many parents may find it just a little too dramatic for their tastes.

This high-contrast technique works best with children of about six months, according to Margo van der Vooren. "I like the expression, with the eyes and mouth wide open, but it's a bit tricky to do properly," she says. "If the face isn't exactly right, it doesn't look so nice." She uses a single spotlight, placed slightly behind the model and shining down onto the face from above. Sometimes she enlists the help of an assistant to catch the child's attention by jangling some keys or making a funny noise. If she's lucky, the child will look up with a quizzical expression, searching in the darkness for the source of the sound.

Nikon F3, 90mm macro lens, Kodak Plus-X. Single spotlight placed above and behind subject, exposure 1/60sec at f/11.

"**This high-contrast technique works best with children of about six months. I like the expression, with the eyes and mouth wide open, but it's a bit tricky to do properly.**"

For this portrait of two young sisters in their bridesmaids' dresses, Vibeke Dahl positioned a single softbox a few feet to the left of the camera, angled downwards. She placed the girls at an angle so that they were facing the light and were evenly illuminated, giving a soft overall effect.

Bronica ETRS, 150mm lens, Agfapan APX 100. Single Hensel Monoblock 800 light used with Bowens Wafer softbox, at an aperture of f/11.

Vibeke Dahl sat these two sisters side by side on a bench, with a single softbox positioned to the left of the camera, angled downwards, about three feet away from them and two feet above their heads. A white melamine trestle table placed in front of them acted as a reflector, throwing light back onto their faces, while the white walls of the studio helped to lift the grey background. "Because of the girls' dark hair and black tops, I opened up by around three-quarters of a stop to compensate for the light absorption," says Dahl.

Bronica ETRS, 150mm lens, Agfapan APX 100. Single Hensel Monoblock 800 light used with Bowens Wafer softbox, at an aperture of f/11.

The effect of studio lighting units can be infinitely varied by the use of supplementary attachments such as softboxes, dishes and snoots, and by altering the intensity of the light and its positioning in relation to the subject. Lighting can also be augmented by reflectors.

A reflector is used to bounce light, either natural or artificial, onto the subject to even up the lighting and to fill in shadow areas. Most commonly, they are used to add detail to the subject's face. There are many commercially available types, most of them circular or rectangular in shape and measuring a few feet across. Most of these are plain white, although there are also gold and silver versions that have their own subtle effects, especially when using colour film.

It's very easy to improvise: you can fashion your own reflectors out of silver foil, mirrors, pieces of polystyrene or even sheets of white paper. White-painted walls will lift the overall brightness of a shot, although you can't use them to direct the light to a specific area. For the shot on the right, Vibeke Dahl used a white melamine table-top, together with a single softbox.

"It's very easy to improvise: you can fashion your own reflectors out of silver foil, mirrors, pieces of polystyrene or even sheets of white paper. White-painted walls will lift the overall brightness of a shot."

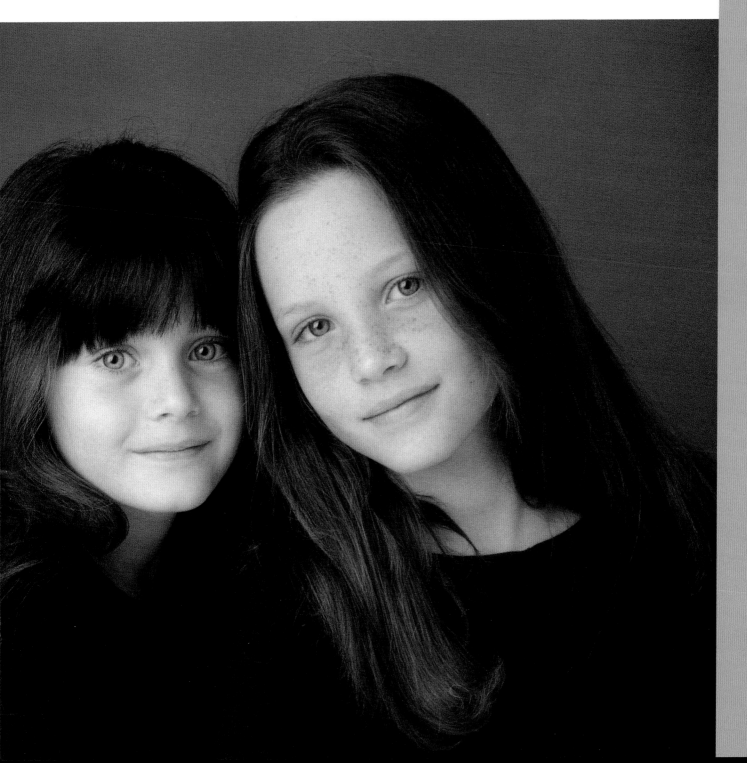

Soft lighting effects can be created simply with both natural daylight and with artificial lighting in the studio. When available window light is harsh and directional, filtering it through a blind, a curtain or a piece of muslin will help to soften it. Alternatively, position the subject away from the strong light source and use a reflector to bounce light back onto their face.

In the studio, softboxes provide a gentle, diffuse form of illumination which resembles natural daylight. Other soft lighting effects can be achieved by filtering studio flash heads through fabric, tissue paper or through specialist attachments such as scrims and barndoors. Using a reflector will help to even out the lighting and fill in the shadows.

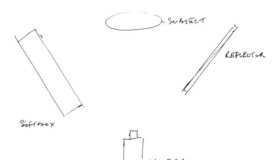

Ronnie Bennett photographed this young cellist in her own home. Because she knew the family well, she was given a free hand to reorganise their living-room, lifting the carpet and removing all the ornaments. The light streaming in through the window was quite bright, but she closed the blinds slightly to make it more subtle. "I originally planned to photograph her playing the cello but I caught her resting for a moment, looking wistful, and I knew that this was my shot," says Bennett.

Bronica ETR-Si, 150mm lens, Ilford HP5, natural window light.

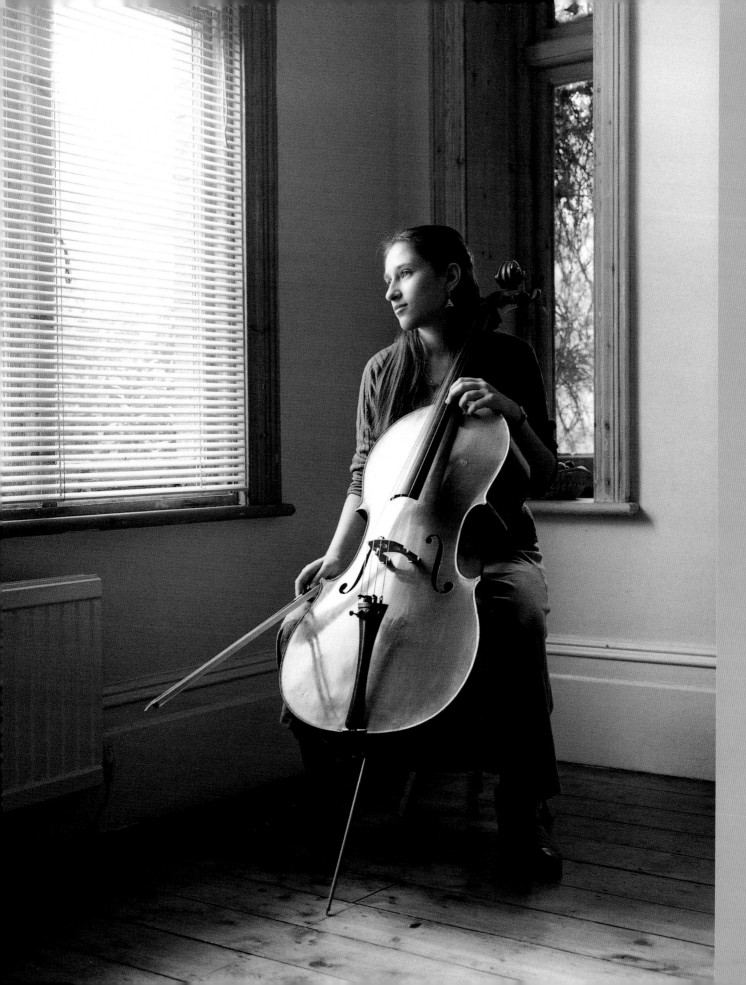

The mirror effect is explained by the girls being identical twins. Tony Hopewell styled them identically in bright red outfits and shot them in the studio against a yellow Colorama background. Two large softboxes provided even lighting, without excessive contrast. The transparency film was then processed in colour negative chemicals.

Hasselblad 201f, 120mm lens, lit by two large Broncolor softboxes. E6 transparency film cross-processed in C-41 chemicals.

Don't be afraid to experiment with different types of lighting. You may have a preference either for studio lighting or for available daylight, but the wider the range of styles you are able to offer, the more potential clients you are likely to attract. Tony Hopewell, for instance, works in a variety of styles, creating subtle, daylight-based portraits one day, bright and colourful studio shots the next.

However great your own versatility, don't lose sight of the comfort of the child. Young children can feel threatened by banks of lights and tangles of wires, and any child will get bored if you are constantly breaking off to take meter readings or to adjust the lighting. Make sure you are thoroughly familiar with all your equipment, and keep it consistent from session to session so that you can operate quickly and with the minimum of fuss.

"One of the great things about kids is their honesty," says Tony Hopewell. "If they aren't happy you can see it – unlike adults, children can't fake it. The photographer has to create a situation in which the child will respond genuinely. This is probably why children's photo shoots are so noisy!"

Tony Hopewell set up a studio shot of this young girl painting as part of an ad campaign for colour photocopiers. It was lit largely by natural daylight, although he supplemented this with a spotlight of a type commonly used in film and TV lighting, to open up the shadows a little. This spotlight was balanced for daylight, which kept the colours looking natural. Hopewell opened the lens right up to f/2.8 to minimise the depth of field and pushed the film by half a stop.

Hasselblad 201f, 110mm lens, Kodak Ektachrome 200. Mix of artificial light and natural daylight.

93

The little girl was shot sitting on the back of a trailer in the Lake District on a very bright day. Her father stood to one side, holding a silver and gold reflector over her face. This kept the light warm but also created some shadow, enabling Annabel Williams to use her preferred aperture of f/5.6. She chose the bright colours of the girl's clothes herself. "The family house was full of brightly coloured cushions and fabrics and I wanted to create pictures that would fit in with that," she says. "When that picture goes on the wall, it will blend in perfectly."

Hasselblad camera, 80mm lens with Softar 1 filter, Fujichrome Provia 400 cross-processed in C-41 chemicals. Exposure 1/500sec at f/5.6.

"I love bright blue swimming pools, I think the colour looks fantastic," says Annabel Williams. "You get lots of reflected light from glass and tiles and a lovely Mediterranean feel." Williams travelled a long way for this session and shot a series of pictures around the family's indoor swimming pool. The children splashing their feet in the water meant that this one worked particularly well.

Hasselblad camera, 120mm lens, Fujichrome Provia 400 cross-processed in C-41 chemicals. Exposure 1/500sec at f/5.6.

Annabel Williams rarely shoots indoors. She might use the studio for preparations and a few preliminary shots, but she invariably moves outside, even if it's raining. "The light's more natural and children feel much more relaxed if they're outdoors," she says. "You're limited in what you can do in a studio; outdoors, kids can run around and find things to do, and you can follow them around and photograph them."

Much of her work is done on location, which often involves working at the client's own home. "I travel a long way to shoot, because I believe you get better results in people's own environment," says Williams. A shoot can take either half a day or a whole day, depending on the type of client, the number of people involved and the distance there is to travel.

Working in the client's home allows Williams to visualise the type of picture that is likely to appeal to them. "I always consider where the pictures are going to go – it's hugely important," she says. "You've got to fit in with people's tastes and going to their homes allows you to see what their style is. I think about everything, right down to the colours the child's wearing, the hair, the location. I'm always thinking about the end product as I go along."

" I think about the colours the child's wearing, the hair, the location. I'm always thinking about the end product as I go along."
Annabel Williams

Backgrounds are just as important when shooting on location as they are in the studio. Ideally, backgrounds should offer a certain amount of detail that will add interest to the picture but not so much that they distract attention from the subject. Walls, doors and the trunks of trees all offer good possibilities. Here Ed Krebs was attracted by the graphic shapes of a wooden fence when working at a swimming pool. He positioned the boy in front of it and framed off-centre, so that the lines of planking led the eye towards him.

Every summer Ed Krebs photographs the members of a junior swimming club at their local pool. Bright sunlight, amplified by reflections from the water and concrete, usually means harsh lighting conditions and makes exposures tricky to calculate. Krebs tries to find a shaded area in which to photograph his subjects; on this particular day this corner was the only one available.

Rolleiflex TLR, 75mm lens, Fuji Neopan 400 developed in PMK Pyro. Exposure 1/60sec at f/5.6.

Ed Krebs' checklist

"Work fast. Children have very short attention spans and will become bored quickly if you spend too much time fiddling with equipment or poses.

"The most important thing is lighting, followed by the background. Even the most beautiful child will look bad if the lighting is harsh or the background is distracting.

"If possible, get the children involved in the shoot. I let them help me carry the equipment from the car and always let them look through the camera. Sometimes I let them take a picture of me or of a sibling. Once I've finished the session the way the parents want it, I ask the children if they want a photograph just for themselves, with their own choice of clothes, props or pets.

"Just as a film has only one director, a shoot should be firmly controlled by the photographer. There's nothing worse than having a mother (or two or three) standing behind you shouting directions on how to smile. I tactfully ask them to leave the area and watch from a distance.

"I almost never say, 'smile'. That's the best way to get an artificial, cheesy expression. If I want to provoke a smile, I try to say or do something silly.

"My personal style is to avoid direct sunlight. Outdoors, I always look for open shade; indoors, for window light. This requires fast film and a tripod.

"I like medium to dark clothing, so that the skin tones are the lightest part of the print. Many photographers like the look you get with white clothes and a white background, but I think that makes the skin tones appear too grey. It's a matter of personal taste."

"I often find a location or texture that I like and then find a person who fits it. Similarly, when I want to photograph a specific person, I spend a lot of time considering the environment in which they are to be seen."

Andrew Ruhl

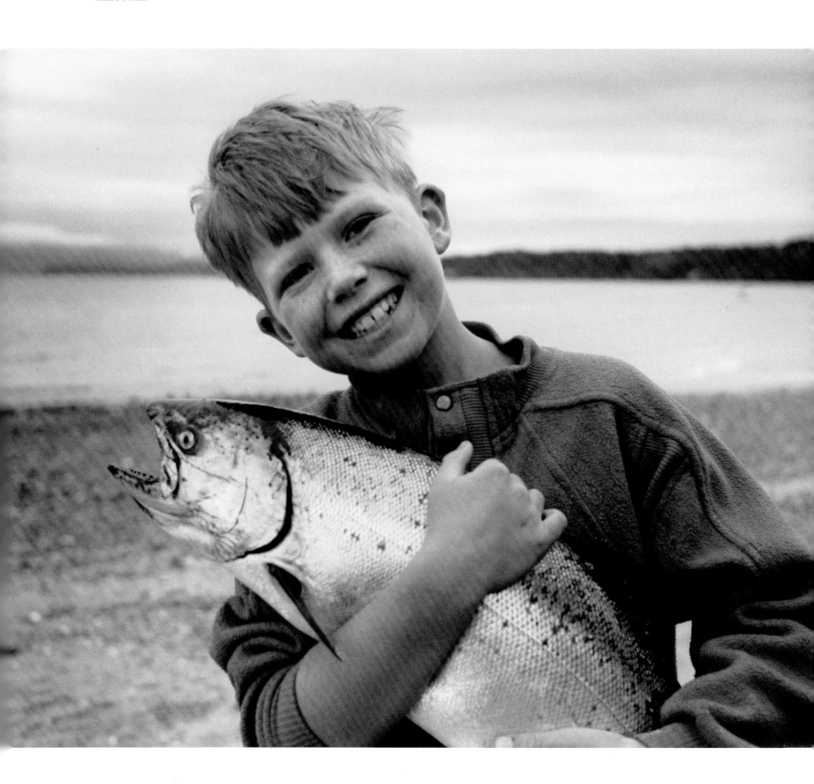

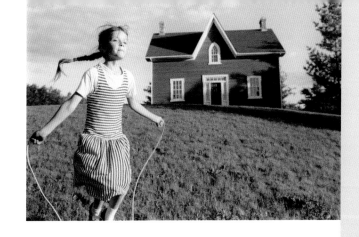

Location portraits can be used to construct a narrative relating to a child's life, depicting specific moments of triumph and achievement or, more simply, showing the child engaged in a favourite activity. Backgrounds play an important role in establishing the mood of the picture, and Andrew Ruhl goes to great lengths to seek out interesting exteriors for his environmental portraiture work.

"I often find a location or texture that I like and then find a person who fits it. Similarly, when I want to photograph a specific person, I spend a lot of time considering the environment in which they are to be seen," he explains. "I enjoy working with kids. I have always found them to be attentive and interested and they have an openness and vitality that invariably comes through." These two images were part of a set of ten limited edition prints that Ruhl recently marketed.

Andrew Ruhl plans his location shots carefully, attempting to match subjects to backgrounds. He was attracted to this hilltop Victorian house, which he thought would make a good backdrop for a portrait. His daughter Addie was available as a model that day and came along with her skipping rope.

Nikon F3, 28mm lens, Leitz tripod and Kodak Tmax 100, printed on Ilford Multigrade IV fibre-based paper.

This shot came about spontaneously. The boy had just caught his first salmon, on a fishing expedition on the west coast of British Columbia. Fortunately Andrew Ruhl happened to have a camera with him and was able to capture the youngster's pride and pleasure in the moment.

Nikon F3, 35mm lens and Kodak Tmax 100, printed on Ilford Multigrade IV fibre-based paper.

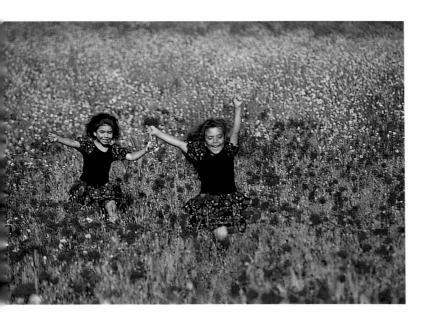

Location work doesn't have to stop once the sun goes in. Every season has its own special flavour and good pictures can be obtained all year round. Autumn, for example, is always a good time for outdoor shots. While the leaves are still on the trees, their rich colours make an excellent backdrop for portraits. When they are lying thick on the ground, you have an excellent opportunity for action shots of children romping around. Bright woolly clothes make a good contrast with the muted colours of the dead foliage.

You can even shoot outside during the winter, but dress your young subjects appropriately to make sure that they are comfortable. A cold child is not a happy child! Action shots are best: running around keeps them warm and gives their faces a healthy glow. If you're careful and plan well, you can get something useable in most weather conditions, short of a howling gale. For inspiration, look at fashion magazines and children's clothing catalogues to see how the photographers go about shooting winter clothing collections.

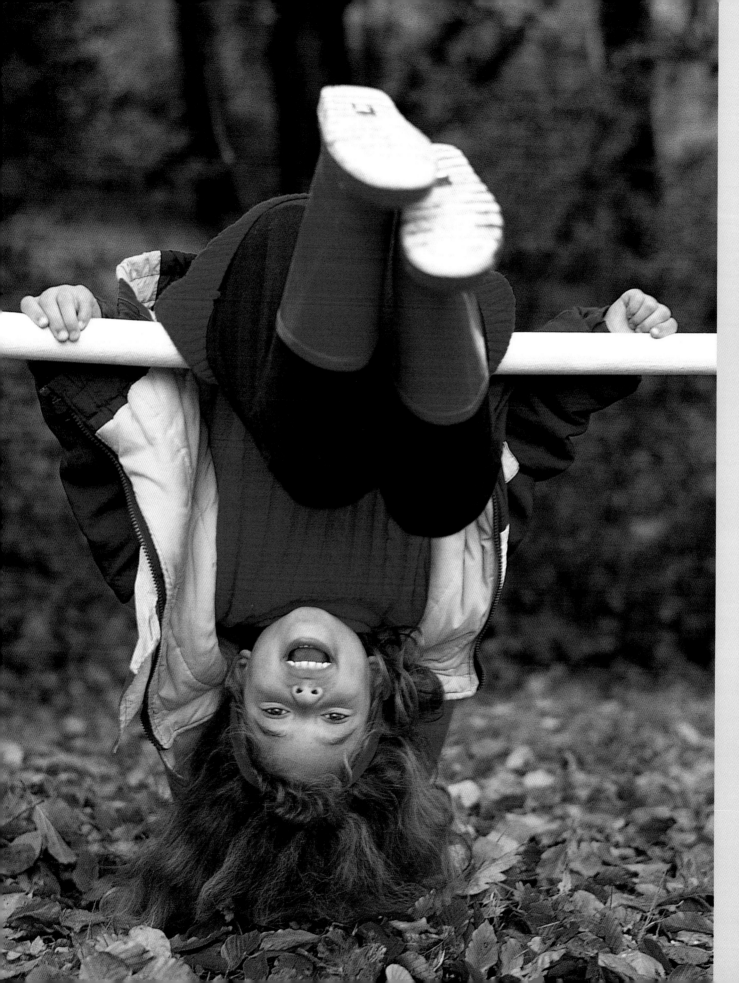

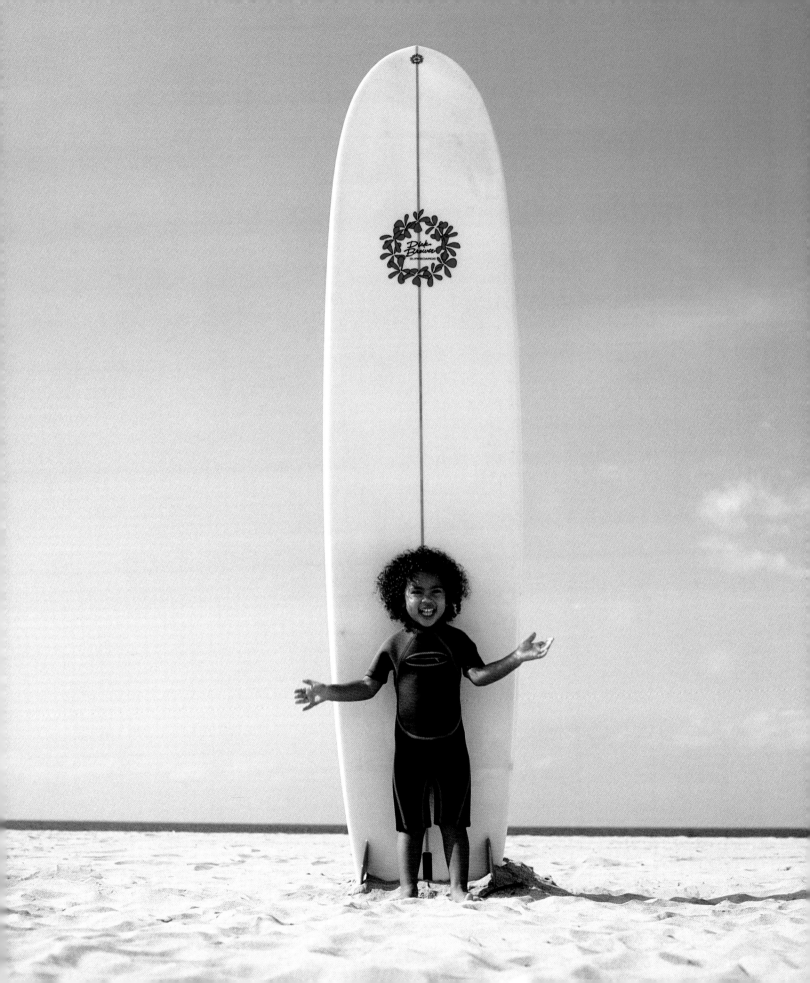

Whether shooting to a commission or working on a personal project, Thaddeus Harden sets out with a clear aim in mind – but he is always ready for the unexpected. "Kids are great for fresh ideas and for bringing the unexpected to the shoot, and sometimes that makes the difference between mundane and magic," he says. "Childhood is a precious but fleeting few years. I try to illuminate the childlike wonder and sense of adventure in my work."

He adds: "The trend is away from the studio 'mass-produced' image, where children appear in fantasy clothing and in situations far removed from their everyday lives. My clients want a more natural, magazine-quality shot."

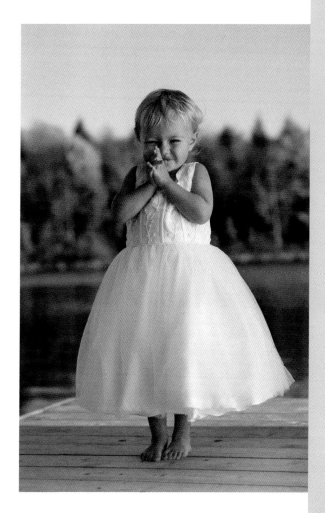

Thaddeus Harden was doing a portrait session with this little girl when the wetsuit in her wardrobe gave him the idea of setting up a 'surf' shot. She wouldn't keep still, but helpers positioned out of shot to either side cheered her on, encouraging her to stay in the right place long enough for him to get his shot. "As much as the magic moment just happens, you have to push it by playing with the child's imagination," says Harden.

Hasselblad, 80mm lens, Kodak 160 NC, natural daylight with white reflectors placed to the left.

"This girl's mother had been trying to get her to wear the white dress for a photo for months, but she was having none of it," recalls Thaddeus Harden. "Then suddenly, the day I was visiting, the capricious tot changed her mind and wouldn't take it off." Harden used a nearby dock as a background: it contrasted nicely with the formality of the dress, as did the girl's bare feet. She was very excited and running around all over the place so, to keep her still, he got her to stand on a 'smiley' sticker placed on the decking. To soften the strong sidelighting he used a large metal mesh scrim, held by an assistant standing just out of shot to one side.

Hasselblad, 180mm lens, Kodak 160 NC, natural daylight softened by 6ft x 6ft scrim.

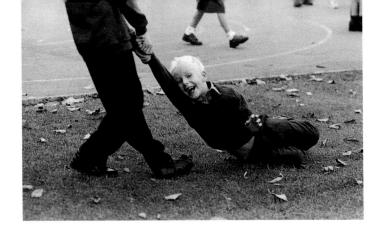

The documentary, or reportage, approach can be very effective when photographing children playing outdoors or taking part in organised sports. Individual faces are recognisable but the pictures have a gritty 'real life' feel to them, as though they have been clipped from the pages of a newspaper or magazine. Often in this type of photography, black-and-white works best.

Richard Bailey was commissioned by a primary school to shoot a set of pictures for its prospectus. He took a number of 'serious' shots of the older pupils studying in their classrooms, but thought that the younger children were having much more fun playing outside. He simply recorded the rough-and-tumble that went on during their lunchbreak and came away with a number of amusing and useable shots. "When working outside with kids, step back a bit and observe their interaction with other children," he advises.

Having done the more 'serious' pictures required for a primary school prospectus, Richard Bailey snatched a series of shots of the younger children at play. Reportage-style pictures show children at their most natural, free from styling and studio lighting effects.

Nikon FE, 135mm lens, Ilford HP5, natural daylight.

As with any assignment involving children, Richard Bailey approached this job with a rough idea of what he wanted to achieve but at the same time stayed alert to the many alternatives. The documentary approach worked well with the playground pictures, creating a sense of immediacy that no set-up shot could hope to achieve.

Nikon FE, 28-85mm lens, Ilford HP5, natural daylight.

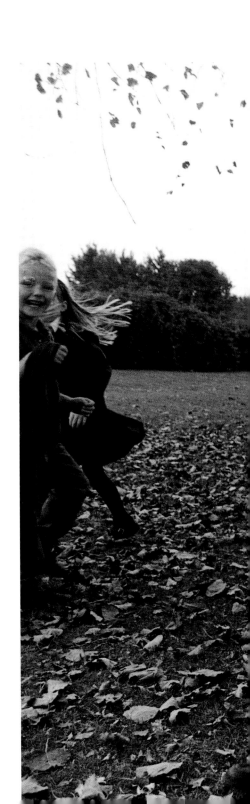

" **When working outside with kids, step
back a bit and observe their interaction
with other children.** "

Richard Bailey

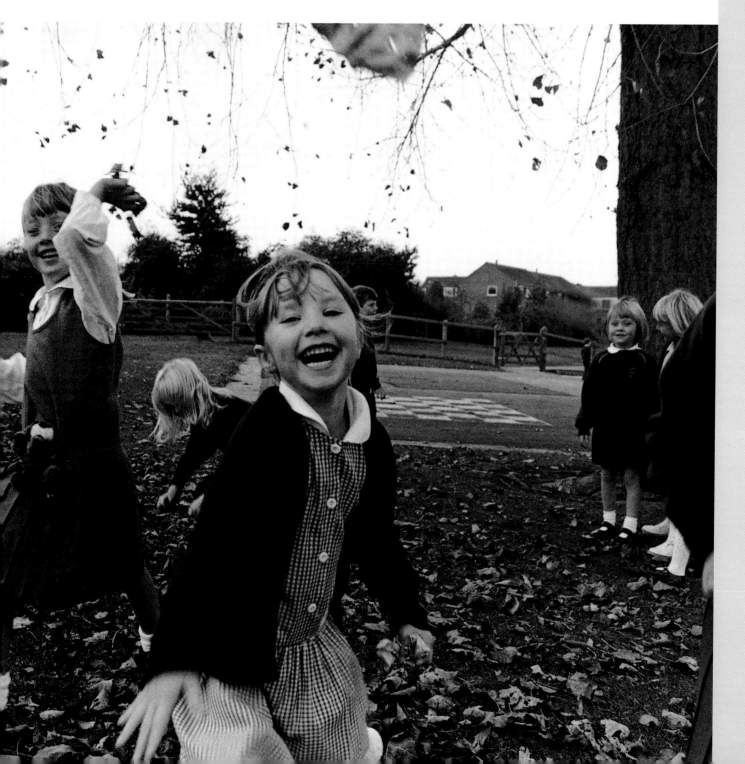

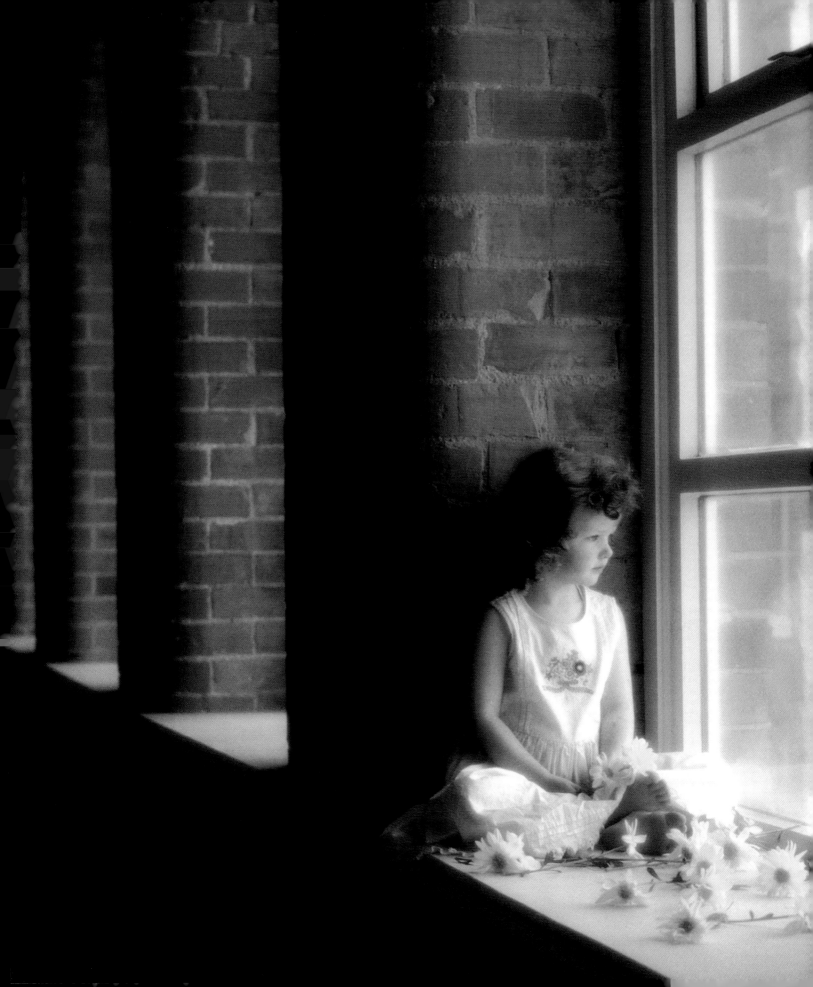

Location work doesn't have to be done outdoors. Many different types of interior can be used for location shots – stately homes, shopping malls, railway stations and farm buildings, to name just a few. Lighting can be provided artificially, but often the best option is to use available light from doors and windows, supplemented by reflectors if necessary.

David Cordner took this dreamy shot of his young daughter Jane in a disused flax mill. "I was experimenting with competitions in mind and visualised the picture before starting," says Cordner. "It was a beautiful building and I wanted to make the most of it. I did some black-and-whites but shooting in colour gave it a different atmosphere. 'Daddy's little girl' was the impression I was trying to create."

David Cordner used an old flax mill as the location for this shot of his young daughter. He planned out the picture beforehand, including the carefully strewn flowers, and used a soft filter to enhance the dreamy mood.

Hasselblad 500CM, 150mm lens, Kodak Ektacolor Pro Gold 160, Softar no 2 filter. Exposure 1/60sec at f/5.6.

Preceding pages: Mindy Myers drove for six hours to record the moment when her friends brought their first child home from hospital. "My goal was simply to record how it felt in their house that day," she explains. "I wanted a family portrait without being too obvious about it, and I also wanted to show how small she was compared with her father's hands."

Nikon F100, 50mm lens, Ilford XP2.

This little girl was photographed at a wedding. The original print showed more of the background, but Mindy Myers scanned it into a computer and cropped in tightly on the face. The sepia effect came from using a chromogenic black-and-white film processed in C-41 colour chemicals.

Nikon FM2, Tamron 35-80mm lens at f/2.8, Ilford XP2.

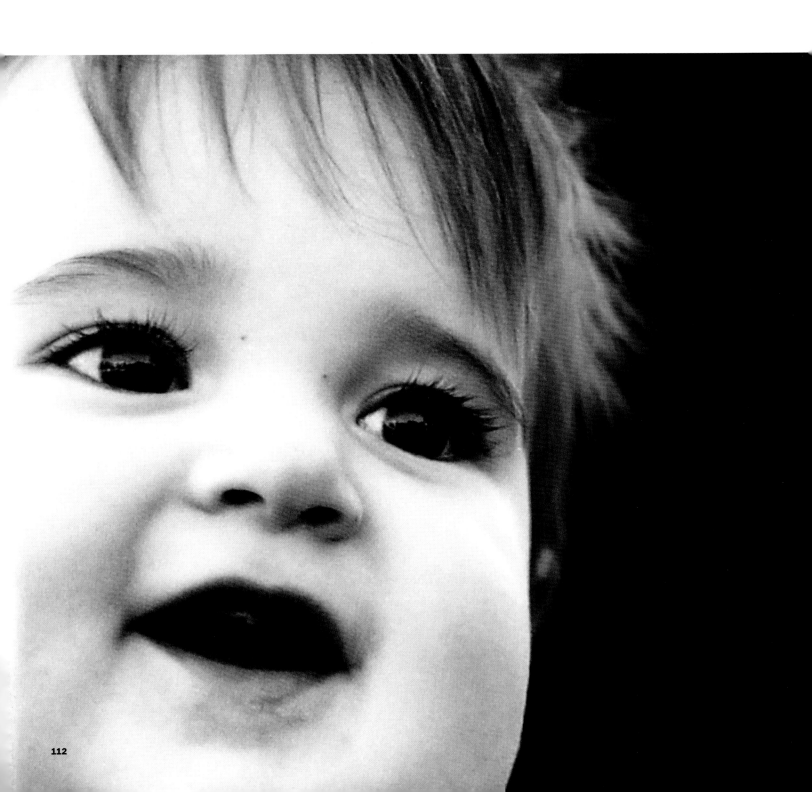

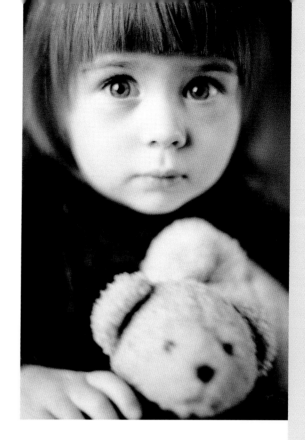

Although they might not be to every parent's taste, big close-ups undeniably pack a punch. The way a picture is cropped dramatically alters its impact, particularly if the subject's eyes are positioned in a prominent part of the frame. Cropping can be done in-camera at the time of shooting or later, during the printing process. Just because you've pressed the shutter, it doesn't necessarily mean the picture is finished.

Close-ups work well in the documentary, or reportage, style of shooting. This is far removed from the static, posed studio shot, having much more in common with the editorial techniques of newspapers and magazines. The aim is to portray subjects in a natural style. For this to work, they need to be comfortable, relaxed and, ideally, hardly aware of the photographer. The best choice of equipment is a light, portable 35mm camera, used with a standard lens or a short zoom.

Mindy Myers studied art at school and college and obtained a degree in journalism. "I think this is why I have a distinctive shooting style," she says. "I have an eye for art, but I know how to view and document the situation in a non-intrusive style."

Mindy Myers photographed her neighbours' daughter in her own simple home studio, using natural daylight. She placed the subject a couple of feet away from a southwest-facing door, and hung a black sheet about five feet behind her as a background. Cropping in close on the child's face, she used an extremely shallow depth of field to concentrate attention on her eyes. The teddy bear's head at the bottom of the frame helped to balance the composition. "She is always quite a serious and adult-like child, and I wanted to capture that," says Myers.

Nikon F100, 50mm lens at maximum aperture of f/1.4, Ilford XP2.

113

This child was very shy to begin with. Including her father in the shot reassured her, as well as providing Margo van der Vooren with a ready-made framing device. For her mono portraits she leaves it up to the customer to decide between sepia and plain black-and-white, although she will advise them to choose sepia if the interior of their house has a lot of warm colours.

Hasselblad, 120mm lens, Kodak Plus-X, lit by a single softbox.

Even when you pull back for a whole-body shot, rather than zooming in on the face alone, pictures benefit from tight cropping and careful framing. If you can find an object or structure that provides a frame for the subject within the image area, it's likely to add cohesion to your composition. Doorways and windows are obvious possibilities; pieces of furniture, garden fences and plants and foliage all offer alternatives. Margo van der Vooren used a couple of empty boxes in one of these shots – and a pair of adult legs in the other.

"Whenever a child is very shy I start off taking pictures like this, with a parent nearby," says van der Vooren. "The child feels safe because daddy is there but, after a while playing hide-and-seek, they usually realise that it's a fun place to be and they don't need their dad any more."

"Children like climbing in things, so I've got loads of stuff they can hide in," says Margo van der Vooren. This symmetrical shot was lit by a single softbox placed to the right of the camera, at an angle of 45 degrees to the subjects.

Hasselblad, 120mm lens, Kodak Plus-X, lit by a single softbox.

Norma Walton does most of her editing in-camera, cropping in tightly to focus attention on a particular mood or expression. She always aims for a natural look, steering clear of unnatural poses and to a large extent allowing the children to direct the shoot.

"Whenever possible I just let them be themselves – it takes longer but usually results in better pictures," she says. "It's important to make sure that the child is participating and enjoying the shoot. I keep talking to them and try wherever possible to communicate with them as equals, rather than talk down to them. I don't

This commissioned portrait was shot in a daylight studio with windows either side supplemented by white reflectors. The little girl was happy in front of the camera and so needed very little direction. Norma Walton used natural daylight to backlight her profile, metering from the centre of her face and allowing the background to burn out. Because the studio was so bright, very little fill-in reflection was required.

Nikon F90X, Sigma 28-105mm lens, Kodak Ektachrome 400. Exposure 1/60sec at f/5.6. Image manipulated in Photoshop and printed on watercolour paper.

"If a child is tired or has a cold, it's wiser to reschedule if possible."

Norma Walton

like unnatural grins, though it's difficult sometimes to get a child just to look at you naturally – they think they have to smile for the camera."

It's also important that the shoot is scheduled for a time of day when the child is not tired. "Portrait shoots involving children who are tired or perhaps have a cold nearly always prove unsatisfactory," says Walton. "If it's a commissioned portrait, it's wiser to reschedule if possible. If I'm taking pictures for my own use, I'd rather try another day than force a session on a reluctant subject."

Norma Walton was aiming to create a natural, unposed look suitable for editorial fashion or catalogue use with this shot taken for her own portfolio. The portrait was shot on the same day as the picture opposite, in the same daylight studio. Walton metered manually and shot handheld. She then scanned the image and used Photoshop to correct the colours and to create a stylised graphic effect.

Nikon F90X, Sigma 28-105mm lens, Kodak Ektachrome 400. Exposure 1/60sec at f/5.6. Image manipulated in Photoshop.

This shot was taken during a swimming competition, on a 35mm camera with a 135mm lens. "The light was terribly harsh, with lots of reflections from the white concrete and the water, so I didn't get many good pictures that day," recalls Ed Krebs. "The boy was shaded but the white towels and the lifeguard's chair were in bright sunlight, so it was a very difficult negative to print, requiring quite a bit of dodging and burning. The Pyro developer I use helps to hold detail in the bright areas."

Rolleiflex SL2000F, 135mm lens, Fuji Neopan developed in PMK Pyro.

"It's important to use a small aperture when doing close-ups, because depth of field is very shallow at close range."

Ed Krebs

Ed Krebs lit this studio shot with a single Monolight bounced from an umbrella just to the left of the camera, with a white foamboard reflector placed to the right. Because his 150mm lens was unable to focus at such a close distance, he added a close-up filter. "It's important to use a small aperture when doing close-ups, because depth of field is very shallow at close range," says Krebs. This was taken at f/16.

Mamiya 645, 150mm lens with +1 close-up filter, Fuji Neopan developed in PMK Pyro.

Close-ups can be achieved in a number of different ways. The first, and most obvious, is to get physically close to the subject with the camera. If you want to be less intrusive, keep your distance and use a longer focal length lens. A zoom is particularly useful, offering flexibility in framing and therefore a variety of different crops. Close-up lenses and filters can be used in the studio too. These attachments are available in a variety of strengths and screw onto the camera lens to allow focusing at extremely close distances.

Purists strive to compose all their pictures in-camera, but many shots benefit from a little judicious cropping at the printing stage. This can be done with the aim of tightening up the composition to add impact, or simply to remove unwanted detail at the extremities of the frame. It is also possible to retain the original crop and remove background detail electronically, using an imaging software package such as Adobe Photoshop.

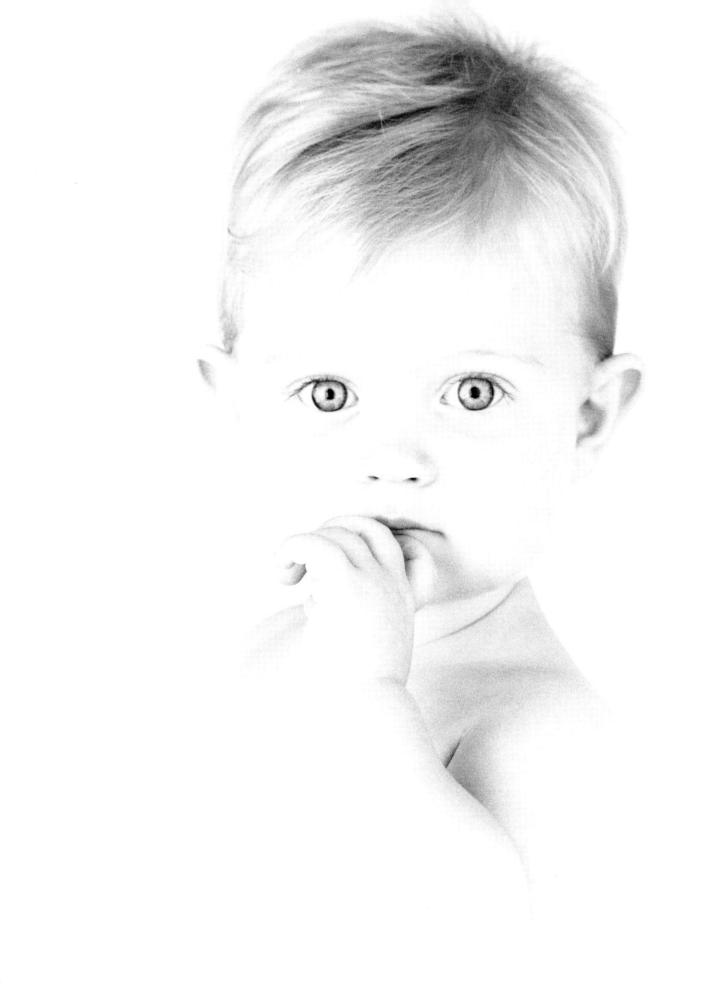

Gerry Coe's pencil portraits are created through a combination of high-key lighting, short negative development times and careful printing on a specialist, single-weight textured paper. Most of the contrast is in the eyes, which means they stand out from the rest of the picture.

Mamiya C330, 135mm lens, Agfa APX 100 developed in Rodinal and printed on Kentmere Document Art paper. Lit by two Wafer softboxes, one either side of the subject, with a reflector beneath the face and two lights on the background.

Gerry Coe shoots most of his pencil portraits on a Mamiya C330 twin lens reflex camera with a 135mm lens. "You don't have to spend thousands of pounds on camera gear to get acceptable results," he says. "The lenses on the Mamiya are perfectly good and you can pick one up secondhand for about £350. As long as it's good quality, it doesn't really matter what equipment you're using."

Mamiya C330, 135mm lens, Agfa APX 100 developed in Rodinal and printed on Kentmere Document Art paper. Lit by two Wafer softboxes, one either side of the subject, with a reflector beneath the faces and two lights on the background.

Gerry Coe's interest in etchings, engravings and mezzotints led him to create a style of picture he dubs his 'pencil portraits'. Resembling pencil drawings, these are high-key studio portraits printed onto textured art paper. They work best with young children, up to the age of about 12, but they're also popular with female clients of any age. They tend to have a flattering effect, masking out any wrinkles and blemishes.

They are created essentially by means of controlled over-exposure. Coe places two softboxes very close to the subject – one either side at a distance of about 3ft – with a reflector in front, angled upwards, to throw light back onto the face, a combination which creates very even lighting. He also uses two spotlights on the background, set at about a stop and a half brighter than the main lights. "I turn the main lights down slightly, maybe from full power to half power, otherwise they would be too bright," says Coe. "I still get a reading of between f/32 and f/64, though I shoot at f/8. In effect, you expose by at least three stops more than the meter reading."

He then develops the film for slightly less than the recommended time. "What you want is a heavy negative but not a contrasty one. Too contrasty, and it won't print well at all," he says. He always prints on the same paper, Kentmere Document Art Grade 2, which has a texture he likes. The vignetting effect is created in the darkroom. "As long as the background is a stop and a half lighter than the subject, it's easy enough to do," says Coe. "You want the shoulders to disappear but you need to keep black in the eyes. The eyes contain all the contrast and are the dominant part of the picture."

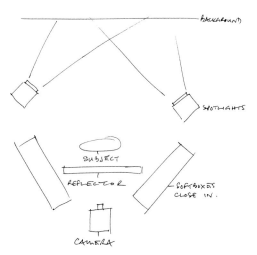

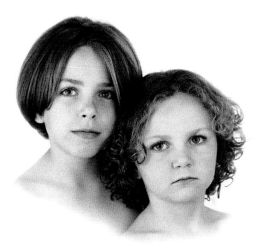

Seventy per cent of Gerry Coe's work comes via word-of-mouth recommendation, while the rest is generated by a display stand at a local shopping centre. The stand is 'non-active': it simply shows examples of his work and provides shoppers with leaflets they can take away. "I don't offer free sittings or free prints," says Coe. "If people come to me, it's because they want to."

The pencil portrait technique is perfect for children but is also suitable for teenage girls or women of any age. The soft, even lighting irons out wrinkles and blemishes and creates a very flattering effect. Coe shoots all his pictures in a 20ft x 14ft studio, and shares his premises with a framing business.

Mamiya C330, 135mm lens, Agfa APX 100 developed in Rodinal and printed on Kentmere Document Art paper. Lit by two Wafer softboxes, one either side of the subject, with a reflector beneath the face.

Gerry Coe takes a hands-on approach to every aspect of his business. He shoots the pictures, processes the film, makes the proofs and the prints, does the retouching, mounts the pictures (always with an overlay mat and on conservation board), frames and glazes them and takes the money at the end. His first-floor studio is located above a shop, and he shares the premises with a framing business. They have common rooms for mounting, finishing and framing, but his 20ft x 14ft studio and reception rooms are separate.

Coe averages between three and five sittings per week and invariably manages to get something useable, even of the most recalcitrant child. He keeps all his negatives and never throws anything away. People can come back for reprints, even years later.

When it comes to orders, he scrupulously avoids the hard sell. "There is absolutely no sales pressure whatsoever," he says. "I'll recommend the print sizes that I feel are right. Sometimes I've told people they're going far too big, that a smaller picture would be better. I try to be honest with them, and it does pay off." It certainly does: 70 per cent of his work comes through word-of-mouth recommendation. The rest is generated by a display stand that he has installed at a local shopping centre.

"Every child is different and every parent's different," says Coe. "The pencil portraits are always a favourite but people want different things, so that's why I take different types of picture. Personally, I prefer the slightly more serious ones. There's certainly a market out there for black-and-white – I'm busy all the time, at least."

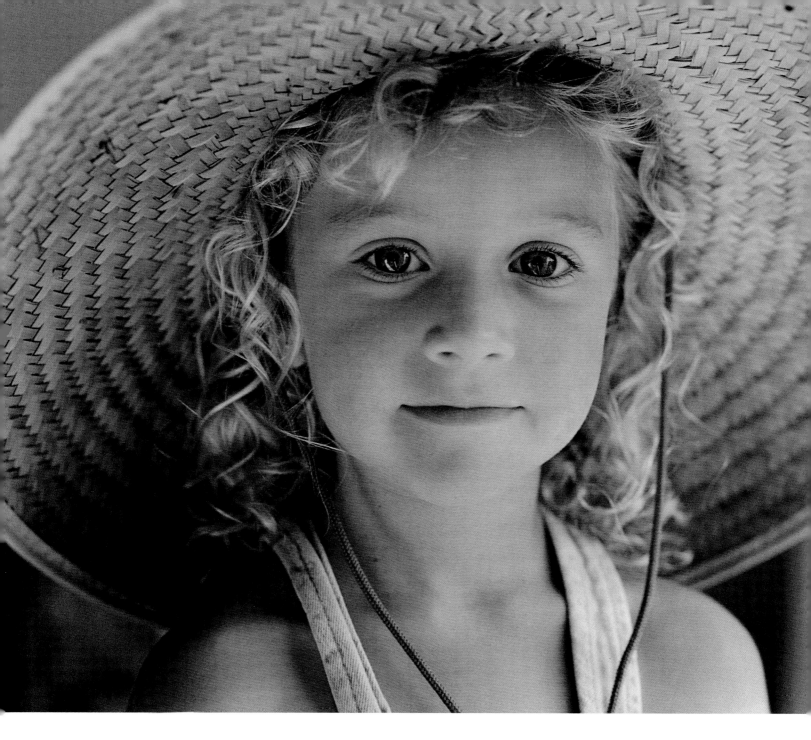

"I find large hats make a wonderful frame for faces," says Ed Krebs. Shooting indoors, using available window light, he used a tripod to hold the camera steady and cropped in tightly, focusing on the little girl's eyelashes. He hand-tinted virtually the whole of the print, leaving only the corners untouched.

Mamiya 645, 150mm lens, Fuji Neopan 400 developed in PMK Pyro. Window light with an exposure of 1/30sec at f/4. Hand-coloured using Marshall's Photo Oils.

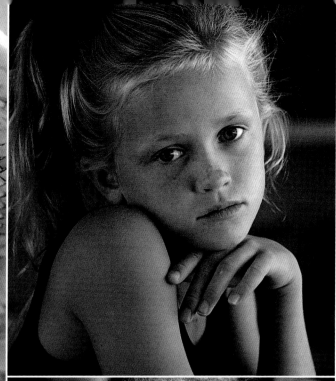

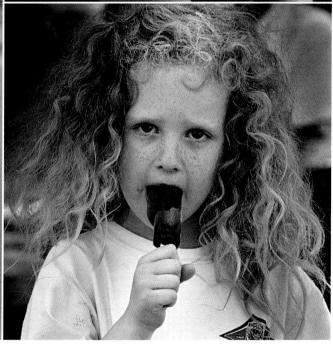

Hand-colouring black-and-white prints is a venerable technique, but it can work particularly well with pictures of children. There are a number of different colouring systems on the market (one of the best-known is Marshall's Photo Oils), and these are generally available from art materials shops or specialist photographic suppliers. Inexpensive alternatives such as food dyes can also be used successfully.

The hand-colouring technique is simple in theory but takes a lot of practice to master properly. Great care should be taken with the combination of colours. With pictures of young children, pastel shades often work best, but it's important to avoid garish, clashing tones whatever the subject.

Ed Krebs sometimes enhances his black-and-white prints with selective hand-colouring, picking out a particular facial feature or highlighting a prop. This imaginative approach can be highly effective, making the highlighted area leap out of the frame in a way that is almost three-dimensional. However, it's a technique that is best used sparingly – if overdone it can appear surreal, and few parents would want a picture that makes their child look odd.

Ed Krebs posed this girl in natural window light, without flash, and used a white foamboard reflector to fill in the shadows. Once the print was developed, he painstakingly coloured it in using Marshal's Photo Oils, selecting the pastel shades that best suited the subject.

Mamiya 645, 150mm lens, Fuji Neopan 400 developed in PMK Pyro. Natural daylight with foamboard reflector; exposure 1/60sec at f/5.6. Hand-coloured using Marshal'ls Photo Oils.

This shot was hand-coloured but instead of working on the whole print, Ed Krebs subtly picked out the details of the ice lolly, the girl's tongue and the logo on her t-shirt, leaving the rest of the print untouched. The result is bold and raises a smile.

Mamiya 645, 150mm lens, Fuji Neopan 400 developed in PMK Pyro. Exposure 1/60sec at f/5.6. Selectively hand-coloured using Marshall's Photo Oils.

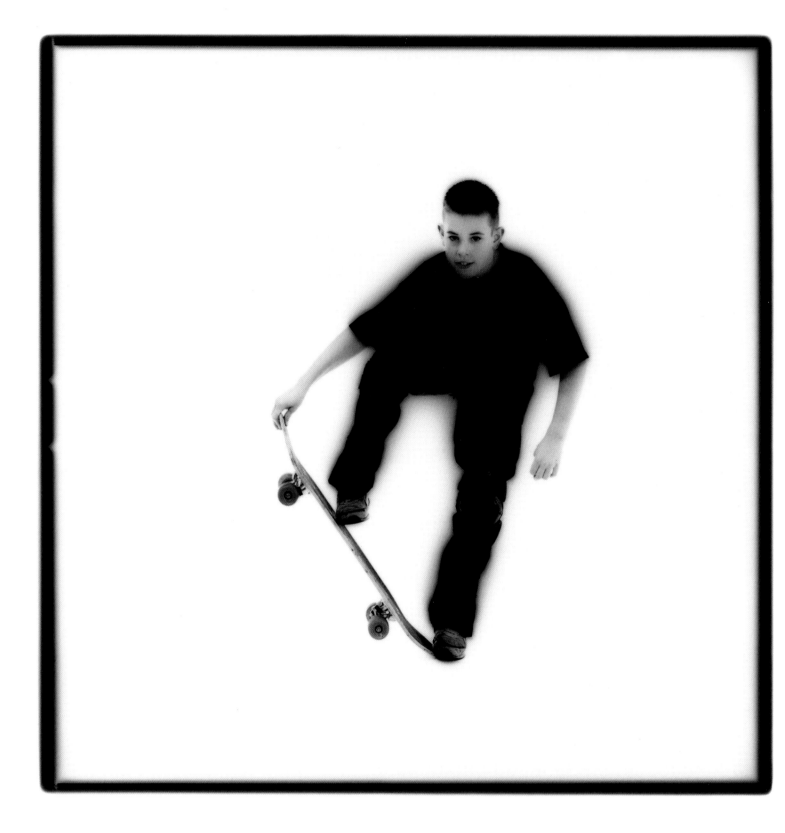

Margo van der Vooren uses cross-processing in combination with a high-key studio lighting set-up, which involves two softboxes to light the subject and a total of four spotlights trained on the white background. The effect is to bathe the subject in light – a clean and simple look, but very effective. "Simple pictures are often very strong – they never get boring," says van der Vooren.

Hasselblad, 150mm lens, Kodak Ektachrome 100 Plus cross-processed in C-41 chemicals. Exposure 1/60sec at f/11.

Cross-processing is a technique favoured by several of the photographers featured in this book. Derived to a large extent from the fashion and lifestyle photography seen in newspapers and magazines, it gives a stylish and contemporary twist to colour portraiture. Only a few years ago cross-processing belonged to the wacky fringes of technical experimentation; now it is finding favour with the mainstream and is increasingly popular with photographers and clients alike.

The concept is simple: pictures are shot on E6 colour transparency film and processed in the C-41 chemicals normally used for colour negative films. The consequences are added contrast and punchier colours, and a contemporary 'feel' that can make conventional colour photography appear rather stilted in comparison. The final effect can vary, depending on the choice of background, lighting, colours and clothing, and whether the shoot takes place outdoors or in the studio. Compare, for example, Annabel Williams' outdoor location shots with Margo van der Vooren's high-key studio portraits.

It is possible to do things the other way around and process C-41 colour negative film in E6 chemicals, but it's not really advisable. The resulting 'transparency' will be low in contrast and the colours badly distorted by the orange mask layer in the film.

When she prints her cross-processed negatives, Margo van der Vooren diffuses the image slightly to soften it. The borders are created simply by including the dark edges of the film frame around the negative. She also uses a special mask in the enlarger to avoid straight edges and to ensure that the borders remain slightly fuzzy.

Hasselblad, 150mm lens, Kodak Ektachrome 100 Plus cross-processed in C-41 chemicals. Exposure 1/60sec at f/11.

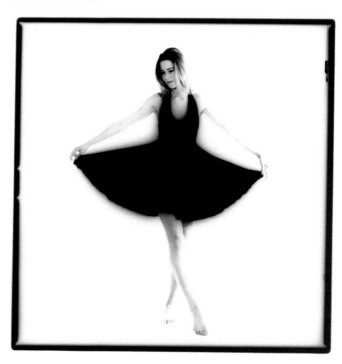

129

Digital photography has gained a huge amount of ground in recent years, but it doesn't necessarily involve shooting with a digital camera. More commonly, prints and transparencies are scanned into a computer and manipulated with a software imaging package, before being printed out onto high-quality paper. Of course, this means spending a significant amount of money to acquire a scanner, computer and printer, as well as the software itself, but a lot of photographers are finding the investment worthwhile, as it increases their versatility and creates the potential for more picture sales.

Perhaps the most popular electronic imaging package – and the nearest there is to an industry standard – is Adobe Photoshop, although there are others on the market. Using a package of this type allows the photographer to create a whole range of effects, including sepia and colour tints, soft focus and a variety of different frames and surrounds. Contrast and colours can be adjusted, blemishes can be airbrushed out, pictures can be cropped and unwanted details can be removed altogether. The possibilities are, in theory, endless – but in practice digital imaging should be approached with restraint. Portraits subjected to a whole battery of weird and wonderful effects are not necessarily the ones that will appeal to the client.

Variations on a theme: this high-key portrait appears in chapter 6, but here is printed with slightly warmer tones. Having scanned the image into a computer, Margo van der Vooren manipulated it in Photoshop, achieving an effect similar to that of a Polaroid transfer (a technique in which the emulsion layer of a Polaroid print is soaked and then carefully peeled off). "I'm working on my Photoshop, but still like conventional photography better," says van der Vooren.

Hasselblad, 120mm lens, Kodak Vericolor 160 Pro. Two softboxes for the subject, two spotlights on the background. Image manipulated in Photoshop.

"If you don't shoot it, you can't sell it."
David Cordner

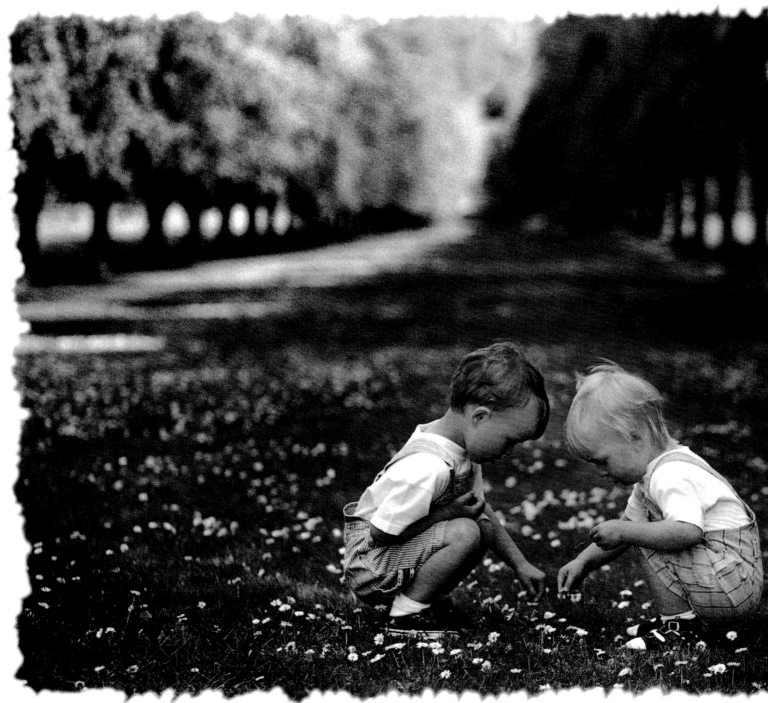

Software packages such as Photoshop are very accessible but not everyone makes the most of them, according to David Cordner. "Some of the bizarre effects you can create are interesting, but a lot of photographers overdo it," he says. "I only retouch what I need to retouch. I don't use digital imaging to create things, only to enhance. I'm quite conventional in that respect."

This image was subjected to quite a lot of work, although the effect is very subtle. Cordner shot the two young brothers on location at Stormont Castle in Belfast but, on viewing the result, decided that the building in the background was too distracting. Having scanned the image into his computer, he went to work with Photoshop, airbrushing out parts of the building and 'cloning' the trees to create an artificial avenue. He added the frame effect painstakingly by hand; later versions of Photoshop include a function that can do this automatically.

Digital retouching can rescue a picture that doesn't quite come up to the mark. It makes more sense than ever to shoot what you can, even in adverse conditions, so that you have at least some raw material to work with. "If you don't shoot it, you can't sell it," reminds Cordner.

The carpet of daisies provided a perfect distraction for the two young brothers, but David Cordner wasn't satisfied with the background. So he created a new one with the help of Adobe Photoshop, airbrushing out the distracting building and pasting in an avenue of virtual trees with the program's cloning tool. He then added a sepia wash to the image and finished it off with a ragged frame effect, which gave it a stylish, antique feel.

Canon EOS 1, 85mm lens, Kodak Tmax 100. Exposure 1/250sec at f/2.8. Adobe Photoshop used for digital retouching and frame effect.

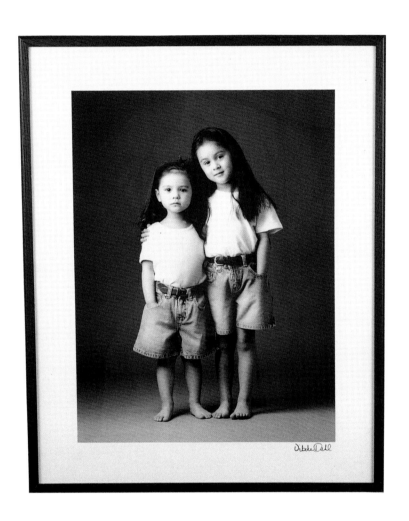

Framing and finishing is the penultimate step in the portrait process: all that remains is to hand over the finished product and accept the client's payment in return. It's worth taking great care over this stage – if a picture is presented shoddily, it will undo all the good work that went into its creation and will damage your prospects of repeat business. The sizes of the frame and surround, as well as their respective colours, affect the way in which an image is perceived, so be sure to choose the materials that best suit your style of photography.

Some photographers do their own framing and finishing; others contract it out to a trusted professional. Either way, it's important that customers have a range of different options to choose from. The frame should not only complement the image itself, but should also be suitable for the room in which it is intended to hang. The attentive photographer will quiz his clients on their interior décor scheme and make a recommendation to match. The clients, after all, will be living with the image for quite some time to come.

Vibeke Dahl has her own distinctive style, which is very popular with her clients: the waiting list for a session at her studio is four months long, all year round. She prints her pictures with white borders, dry-mounts them on a non-textured conservation board, then glazes and frames them, using a plain black wooden frame.

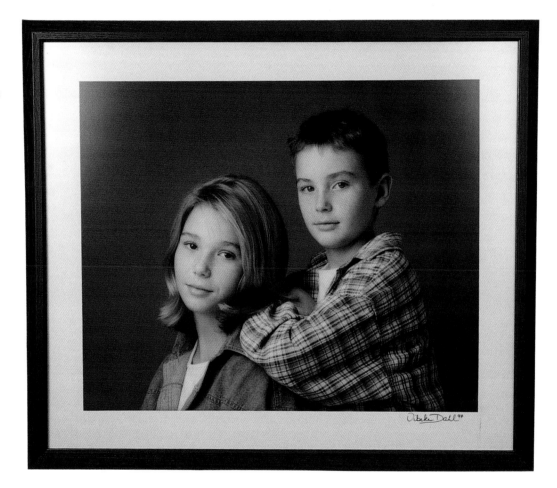

"It's worth taking great care over framing – if a picture is presented shoddily, it will undo all the good work that went into its creation and will damage your prospects of repeat business."

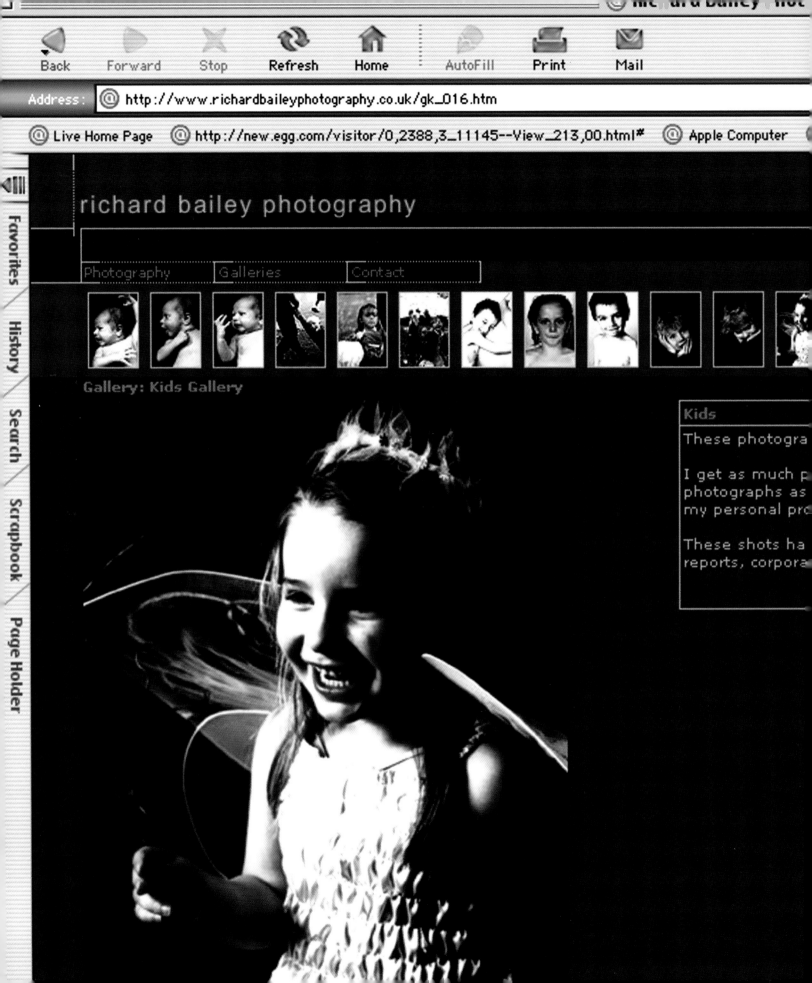

ny. Kids Gallery

e my work-work.

e taking these
aking photographs for

n taken for Annual
:hures and magazines.

marketing & websites

Business rarely comes through the door of its own accord: it's essential to market your work. Word-of-mouth recommendation is perhaps the most satisfactory way of building up your business, but brochures, business cards and other publicity materials all have a part to play, especially when you're starting out. Most of your work is likely to come from families in your local area, so an advert in a local newspaper can pay dividends. Take a great deal of care over the design and presentation of any publicity material: if it's sloppily thrown together, with poor-quality images and lots of spelling mistakes, people will naturally assume that your photography is of a similar standard.

Many photographers now have their own websites, and a well-designed site can be an invaluable marketing tool. It allows potential customers to assess your work quickly and decide whether your style of photography is right for them. It's relatively easy to establish an internet presence: with a modicum of technical knowledge you can do it yourself, but there's no shortage of professional web designers who can set up a site for you, quickly and at a reasonably low cost. Once up and running, sites are inexpensive to maintain and can be regularly updated with examples of your latest work.

Keep your website design clean and simple. Gerry Coe's home page contains four main links representing each of his areas of expertise. Clicking on one of the images takes the visitor to a page containing further examples of that type of photography. Other links connect to pages containing a brief biography of the photographer and the all-important contact details, including a direct e-mail link.

www.richardbaileyphotography.co.uk

Richard Bailey's site contains gallery pages that feature examples of his photography. Clicking on a thumbnail image at the top of the page calls up an enlarged version of the selected picture.

A website acts as a shop window for your talents, so take care not to dilute its impact by making it difficult to use. Keep the design clean and uncluttered, with a relatively small number of pages and a small selection of images on each. If you offer different styles of photography or have different areas of expertise (colour and black-and-white, for instance, or babies and teenagers), allocate a separate page to each. Make the site easy to navigate, with a simple menu and clear click-through links to each page, including a return link to the home page.

Limit your choice of images to a representative sample of your strongest. It's common to design pages so that initially they display only a series of thumbnail images; the user clicks on the thumbnail to see an enlargement of the image. Steer clear of unnecessarily complex click-through windows and jazzy extras: on the internet, speed is everything and a site that takes ages to download is sure to lose the attention of the casual visitor. For the same reason, keep image files relatively small and low-resolution. Perhaps most importantly, build in a page with full contact details, including an e-mail link. If customers don't know where to find you, you won't win their business.

www.portrait-art.co.uk

David Cordner's site functions on the same principle, but has a slightly different design. Clicking on a thumbnail calls up a separate window, which contains an enlarged version of the selected image.

Richard Bailey has been a freelance photographer for ten years, specialising in children, portraiture and corporate reports. He has travelled the world working on personal projects and his book *The Road to Glory: a Portrait of Britain's Paralympians* has won several awards. Some of his work is held by the picture agency Corbis; more can be viewed on his website.

Richard Bailey Photography, 36 Olive Road, London NW2 6UD, UK.
Tel: +44 (0)20 8450 4148
Mobile: +44 (0)7956 971520
e-mail: richard@richardbaileyphotography.co.uk
www.richardbaileyphotography.co.uk

Ronnie Bennett took up portrait photography as a second career in the mid-1990s, after completing a City and Guilds Professional Photography course. Since then she has won more than 40 awards, including the 1998 Fujifilm Portrait Photographer of the Year Award and the 1999 Kodak Children's Portrait Photographer of the Year prize. She is a Fellow of the Royal Photographic Society, an Associate of the British Institute of Professional Photography and a member of the Association of Photographers. Over the past five years she has worked mainly for private clients but is planning to diversify into advertising and editorial portrait work.

Orchard House, West Tisted, Alresford, Hampshire SO24 0HJ, UK.
Tel: +44 (0)1962 773140
Fax: +44 (0)1962 773141

Gerry Coe is the only professional photographer in Northern Ireland specialising in fine-art monochrome portraiture. Working from his studio in Belfast, his work consists predominantly of child and family photography. He is a Fellow of the British Institute of Professional Photographers and in 1999 received the prestigious Peter Grugeon Award for best fellowship panel, as well as two gold and two silver awards in the BIPP National Print Exhibition. He is a Fellow both of the Royal Photographic Society and of the Master Photographers Association, and in 1999 won the Agfa UK & Ireland Portrait Photographer of the Year Award.

Lasting Image, 667 Lisburn Road, Belfast BT9 7GT, UK.
Tel/fax: +44 (0)28 9066 8001
e-mail: gcoe.photo@cwcom.net
www.lasting-image.co.uk

David Cordner has spent 18 years as a photographer, running his own business for most of that time. He began by doing general-purpose wedding and society work but a few years ago decided to specialise in family photography. He prefers to work on location rather than in the studio. He has won five Kodak Gold Awards and in June 1999 was named BIPP Portrait Photographer of the Year.

Portrait Art, 5 Thorndene Park, Carrickfergus, Co Antrim, BT38 9EA, UK.
Tel: +44 (0)28 9336 6190
e-mail: david@portrait-art.co.uk
www.portrait-art.co.uk

Vibeke Dahl works from an attic studio on the outskirts of London and since 1982 has specialised in black-and-white portraits of children. She is an Associate both of the British Institute of Professional Photographers and of the Master Photographers' Association. Originally from Norway, she graduated in graphic design from Westerdals School of Commercial Art in Oslo, followed by three years studying photography at West Surrey College of Art and Design in the UK. She has won numerous awards for her work.

Vibeke Dahl Photography, 18 Beechwood Avenue, Kew, Richmond, Surrey TW9 4DE, UK.
www.dahlphoto.co.uk

Angela Hampton started out photographing her own daughters and their friends and is now one of the UK's top child photographers, supplying a long list of parenting and lifestyle magazines and book publishers. Her picture library contains over 50,000 photographs of children, adults and pets, many taken in natural, available light.

Family Life Picture Library,
Holly Tree House, The Street, Walberton, Arundel, W Sussex, BN18 0PH, UK.
Tel/fax: +44 (0)1243 555952

Thaddeus Harden photographs children for editorial and advertising clients. He has completed more than 130 children's book assignments, and loves to express in his imagery the joy and wonder of being a child. He is based in New York.

Tel: +1 212 439 8363
e-mail: thaddeus@thaddeusharden.com
www.thaddeusharden.com

Tony Hopewell has worked as a photographer for more than 20 years, specialising in people – and children in particular – for the past 15. He has a huge amount of studio and location experience, shooting children and children's fashions for catalogues and major high street clients such as Boots, Monsoon, Ladybird and Mothercare. He also works on major advertising campaigns, both in the UK and abroad, for clients such as Microsoft and Canon.

Tel: +44 (0)70 107 10050
e-mail: tony@tonyhopewell.com
www.tonyhopewell.com
Represented by: Julian Cotton, 55 Upper Montagu Street, London W1H 1FQ, UK.
Tel: +44 (0)20 7723 3100
e-mail: julie@juliancotton.co.uk
www.juliancotton.co.uk

Ed Krebs was first drawn to photography in the 1960s by magazines such as *Life*, *Look* and *National Geographic* but didn't take it up seriously until 1989, when a friend gave him some darkroom equipment and he taught himself to use it by reading all the specialist books in the public library. He was immediately drawn to black-and-white and soon developed a fascination with photographing children and animals – he claims he still can't take a decent landscape. He enjoys using old, manual equipment, especially Rolleiflex cameras, and prefers straight, unmanipulated photographs. However, he does enjoy hand colouring (and has written a book on the subject).

Ed Krebs, Laguna Beach, California, USA.
Tel: +1 949 499 3061
e-mail: ekphoto@yahoo.com
www.edkrebs.com

Mindy Myers studied photography and art at the University of California, Santa Barbara, before finishing her journalism degree at Drake University. Her photography won her several national awards while at university, and her education helped shape a signature style of documentary portraiture – a gentle, authentic approach that she calls 'natural child photography'. She invests a great deal of time in her portraits, developing a rapport with the children and creating an environment in which they feel at their ease. She lives in Des Moines, Iowa.

e-mail: mindy@mindymyers.com
www.mindymyers.com

Andrew Ruhl developed an interest in photography in his teens and started work as a photographer in his early 20s. He later spent many years of his career in the film and video business. He continues to work seriously as a photographer, although these days he approaches picture-taking as an art rather than a labour. He has pursued a number of different styles over the years but now works exclusively in black-and-white, with most of his work being environmental portraiture. He is based in Guelph, Canada.

Tel: +1 519 836 8905
Fax: +1 519 836 4809
e-mail: adruhl@sentex.net
www.sentex.net/~mad/

Margo van der Vooren took up photography in 1983 after swapping sports school for art school, and now specialises in children's photography, glamour (she's also a make-up artist and hair stylist) and weddings. In 1996 she entered her first competition and won a Kodak European Gold Award. Since then she has won many other accolades, including wedding and portrait awards from the Dutch Institute of Professional Photographers (DIPP) and, in 2000, an Agfa European Gold Award. In 1999 she gave a series of photographic seminars in Germany and was a jury member for the Kodak European Portrait Award; in 2000 she gained her DIPP Fellowship. She runs her studio together with her husband, who is also a photographer, and has two children, Mick and Sabine, who are frequently recruited as models.

Van der Vooren Fotografie, Plantsoen 4, 3441 EK Woerden, The Netherlands.
Tel: +31 (0)348 41 34 23
e-mail: cairn@planet.nl

Norma Walton is a full-time freelance photographer. She began by taking photographs of her own children, before taking a City and Guilds course in documentary photography and undertaking portrait and wedding commissions. Her pictures have been displayed in national exhibitions and at the Association Gallery in London, and she has held solo exhibitions in Taunton and Exeter in south-west England. Her flower and still life images are held by Flowers and Foliage library and sell worldwide as greetings cards images. She is aiming to develop her child portrait work for advertising, editorial and catalogue use and in 2001 was planning further exhibitions.

23 Reed Close, Bridgwater, Somerset
TA6 6UX, UK.
Tel: +44 (0)1278 426362
e-mail: norma@walton.demon.co.uk
www. walton.demon.co.uk
www.photo-agent-tc.demon.co.uk/norma.htm

Annabel Williams is a pioneer in the field of contemporary lifestyle photography and has established herself as one of Europe's top social photographers. Based in the English Lake District, she works with her sister, make-up artist Lucinda Hayton, to create a relaxed and natural portrait style. Frequently featured in magazines and newspapers, her pictures have won her numerous awards, including those of Fujifilm Wedding Photographer of the Year in 1999 and Portrait Photographer of the Year in 2000. She has appeared often on TV, recently fronting a series of five programmes for the BBC, while her book *Commercial Portraits* appeared in this series in 2000, followed by *Commercial Weddings* in 2001. She also runs her own training company – Contemporary Photographic Training – which aims to share her innovative vision with others working in the field.

Annabel Williams Studio, Station Road, Stavely, Kendal, Cumbria LA8 9NB, UK.
Tel: +44 (0)1539 821907
e-mail: studio@annabelwilliams.com
www.annabelwilliams.com

Acknowledgements

Many thanks are due to Sarah Jameson, who did the picture research and tracked down so many excellent contributors; to Kate Stephens, who designed the book and did the illustrations; and to editor Angie Patchell, who developed the idea and who supported and encouraged throughout. Most of all, though, I'd like to thank all the photographers who so generously contributed their time, their expertise and their images.